Lessons from the Beach

Reflections from Fire Island

Photography and reflections by Robert Bonanno

Copyright 2008 By Robert Bonanno

All rights reserved. No part of this book may be reproduced or transmitted in any other form or by any means, electronic or mechanical , including photo-copying, recording or by any other information storage and retrieval system, without written permission in writing from the author.

IBSN 978-0-6151-8511-8

Acknowledgments

Special thanks to the following:

Mr. George Bolender for giving me a place to view the beach from.
My salon clients for encouragement and input.
The Fire Island Pines for the inspiration, joy, and fun at all times.

To T.B.

The best....
Who showed me how to
learn from the beach.

When you're still
and listening the
beach will help you
find the answers.

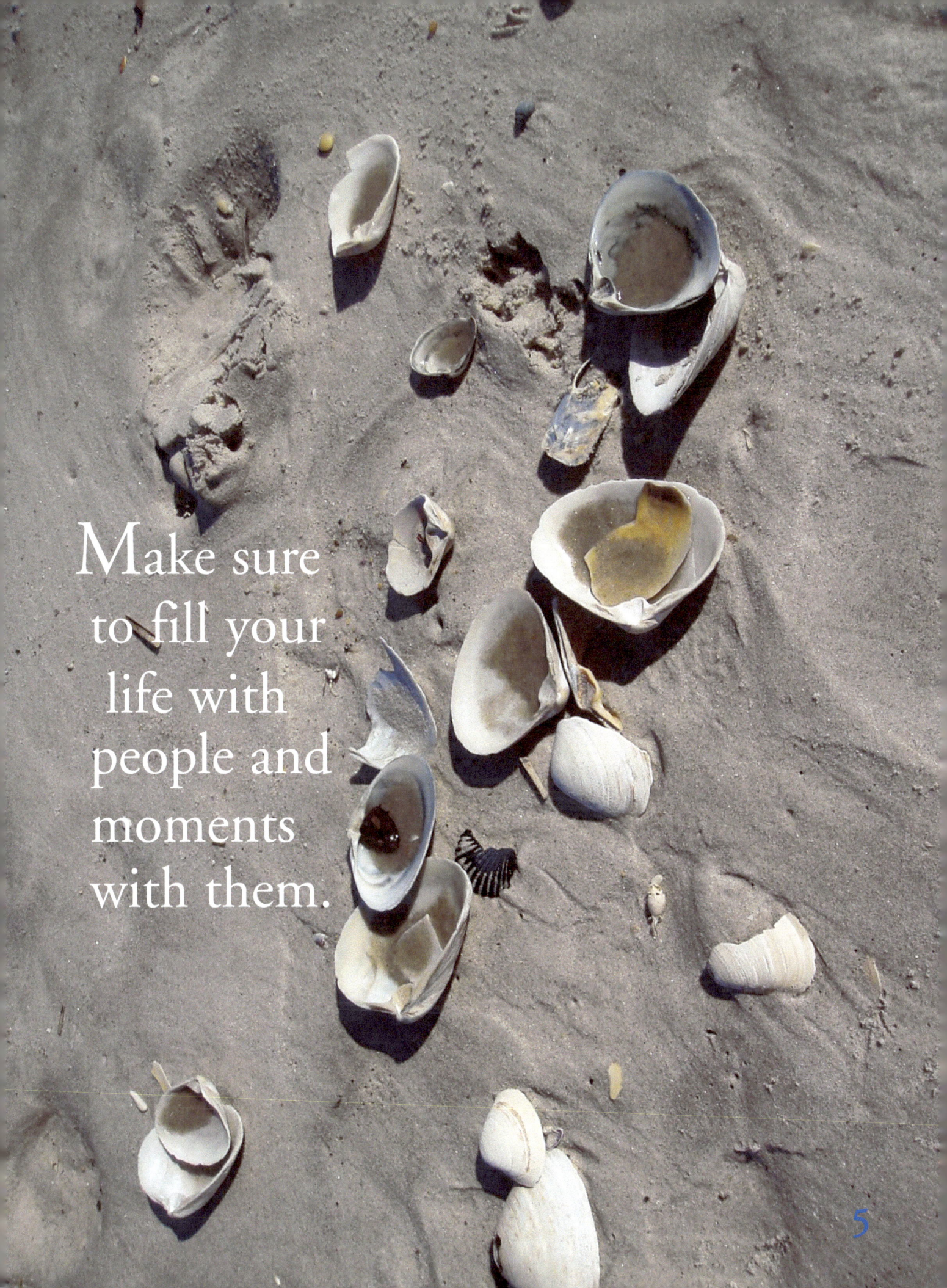

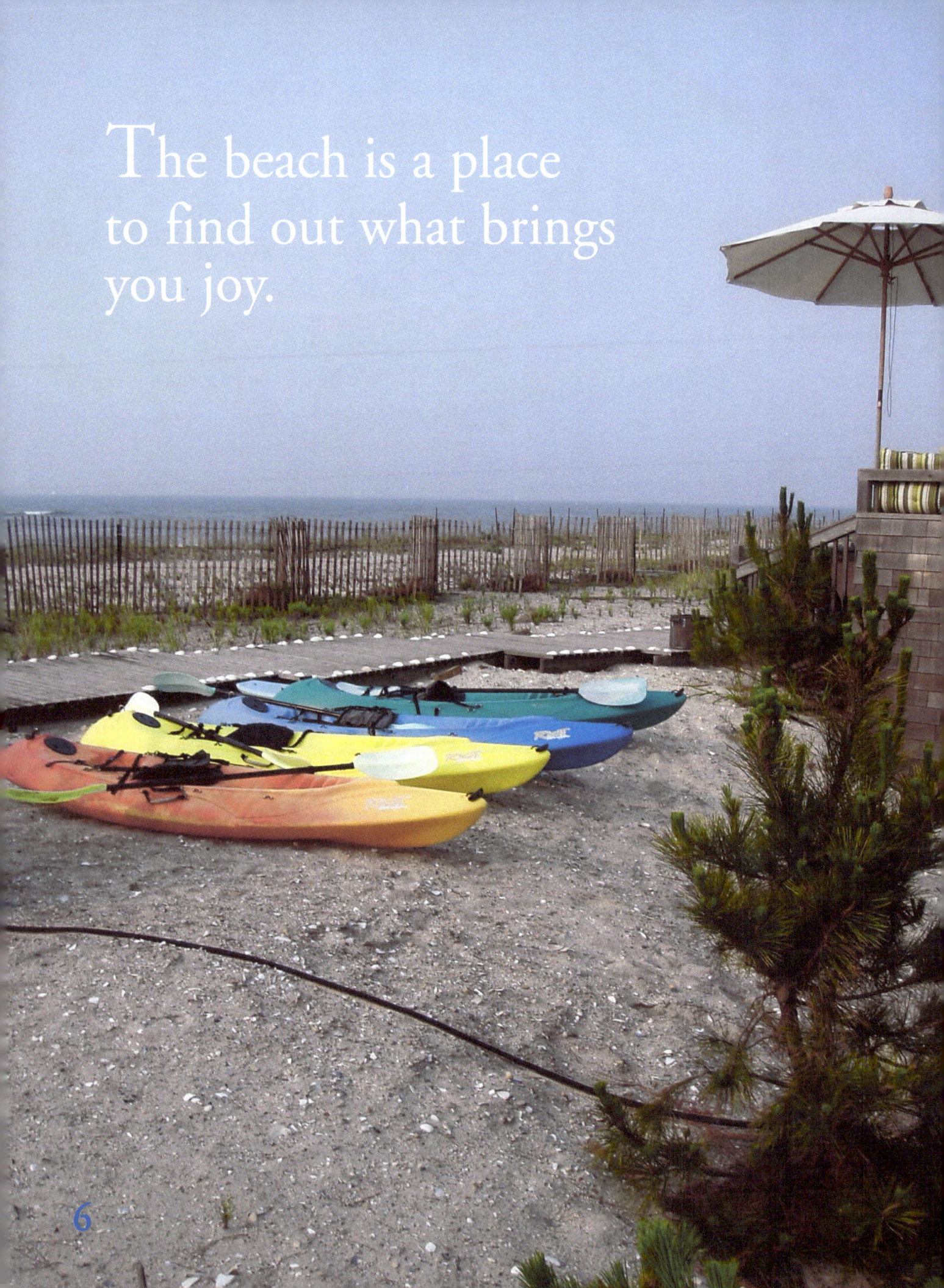

The beach is a place to find out what brings you joy.

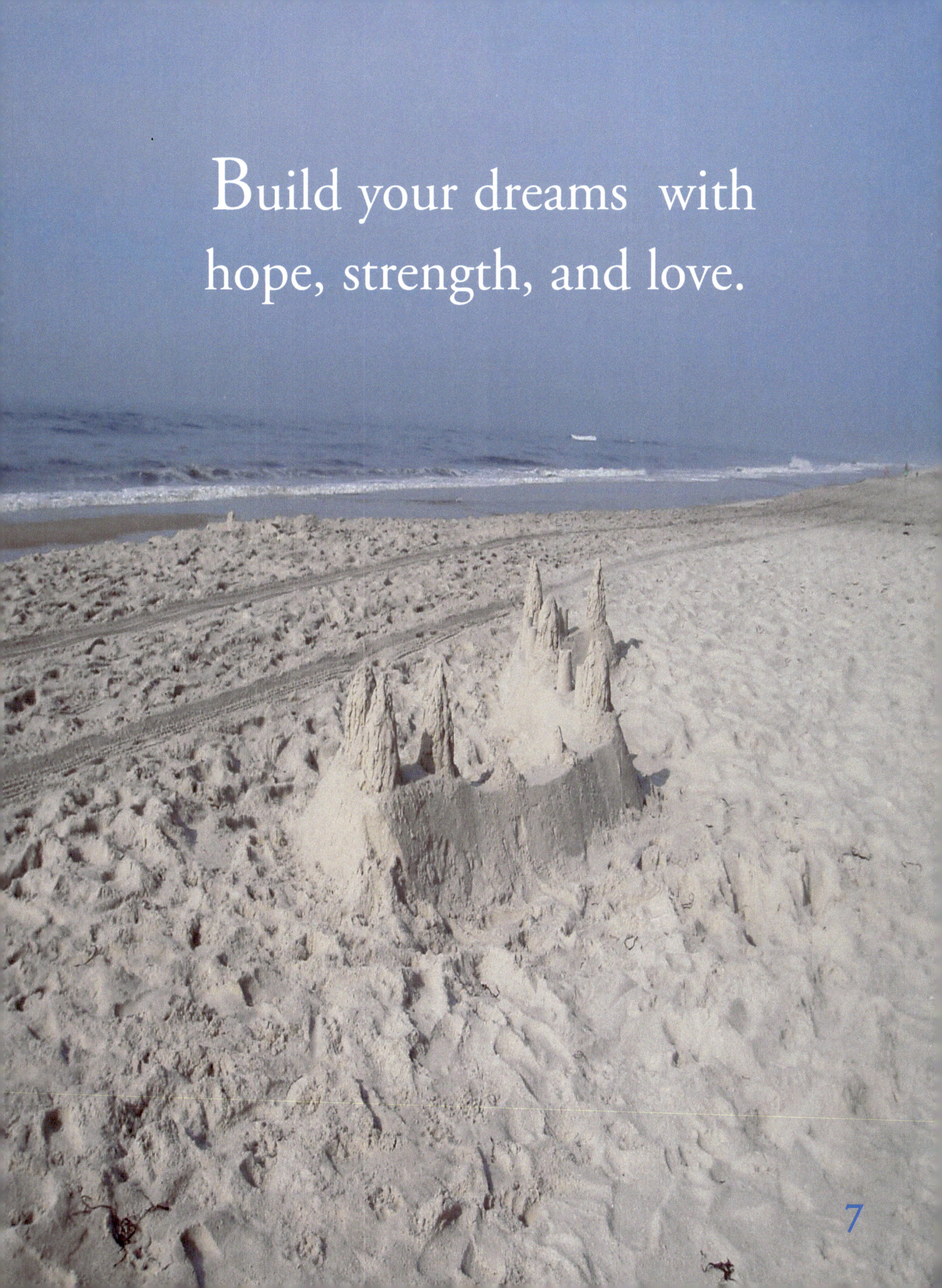

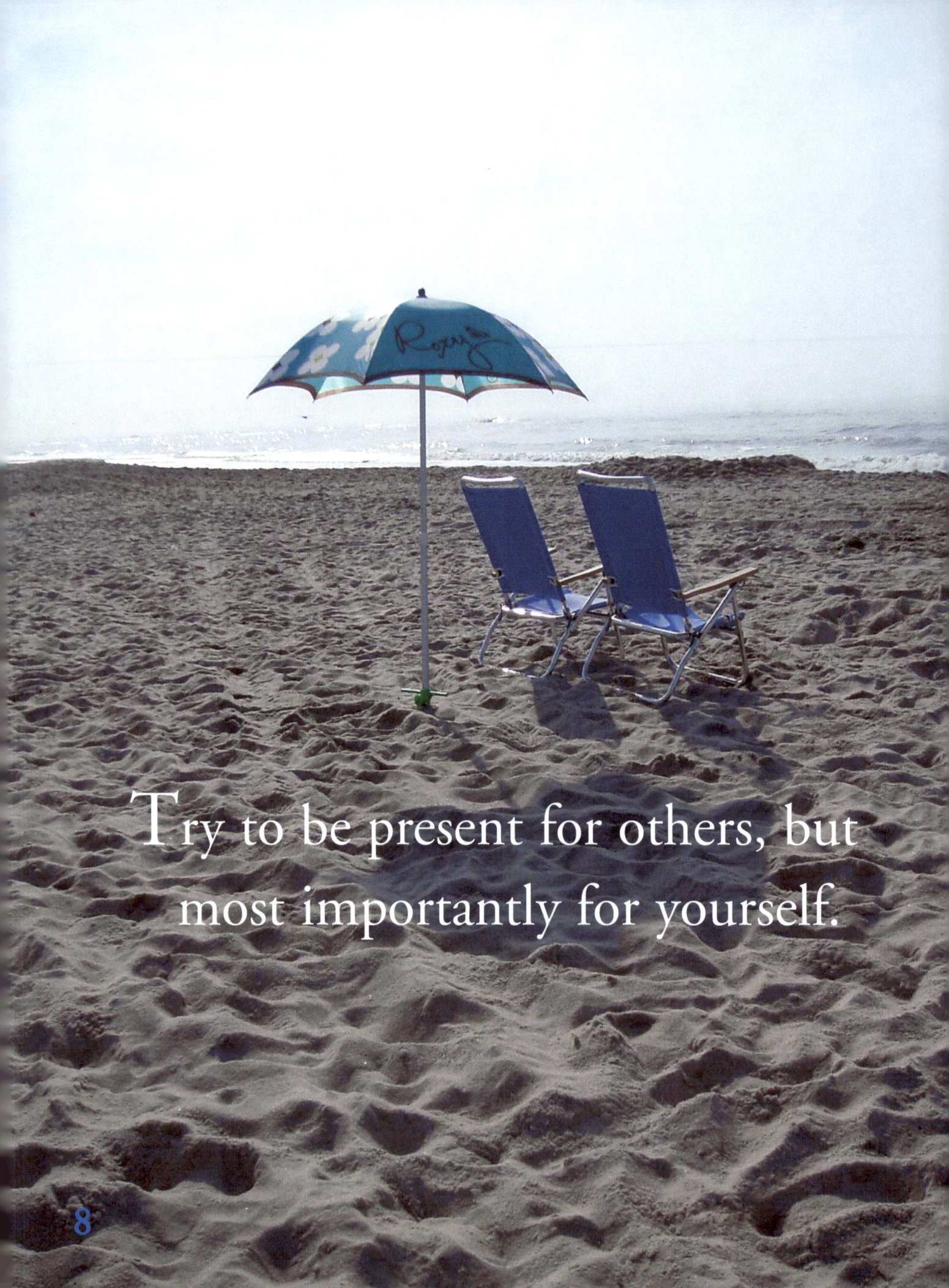

Sometimes it's a choice between the easier way, and walking the walk.

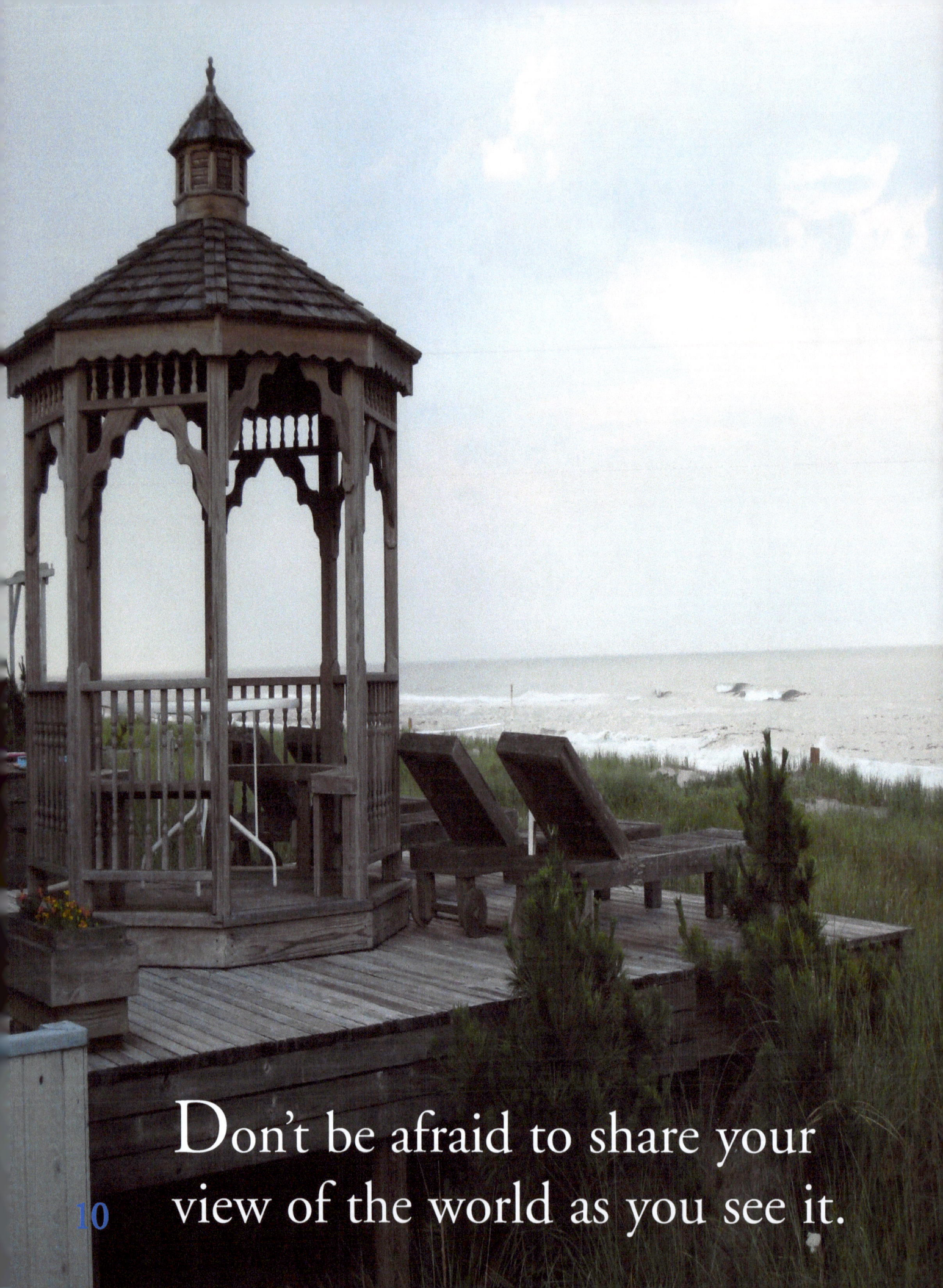

Don't be afraid to share your view of the world as you see it.

Like the beach our lives can become eroded. We need to create ways to protect ourselves.

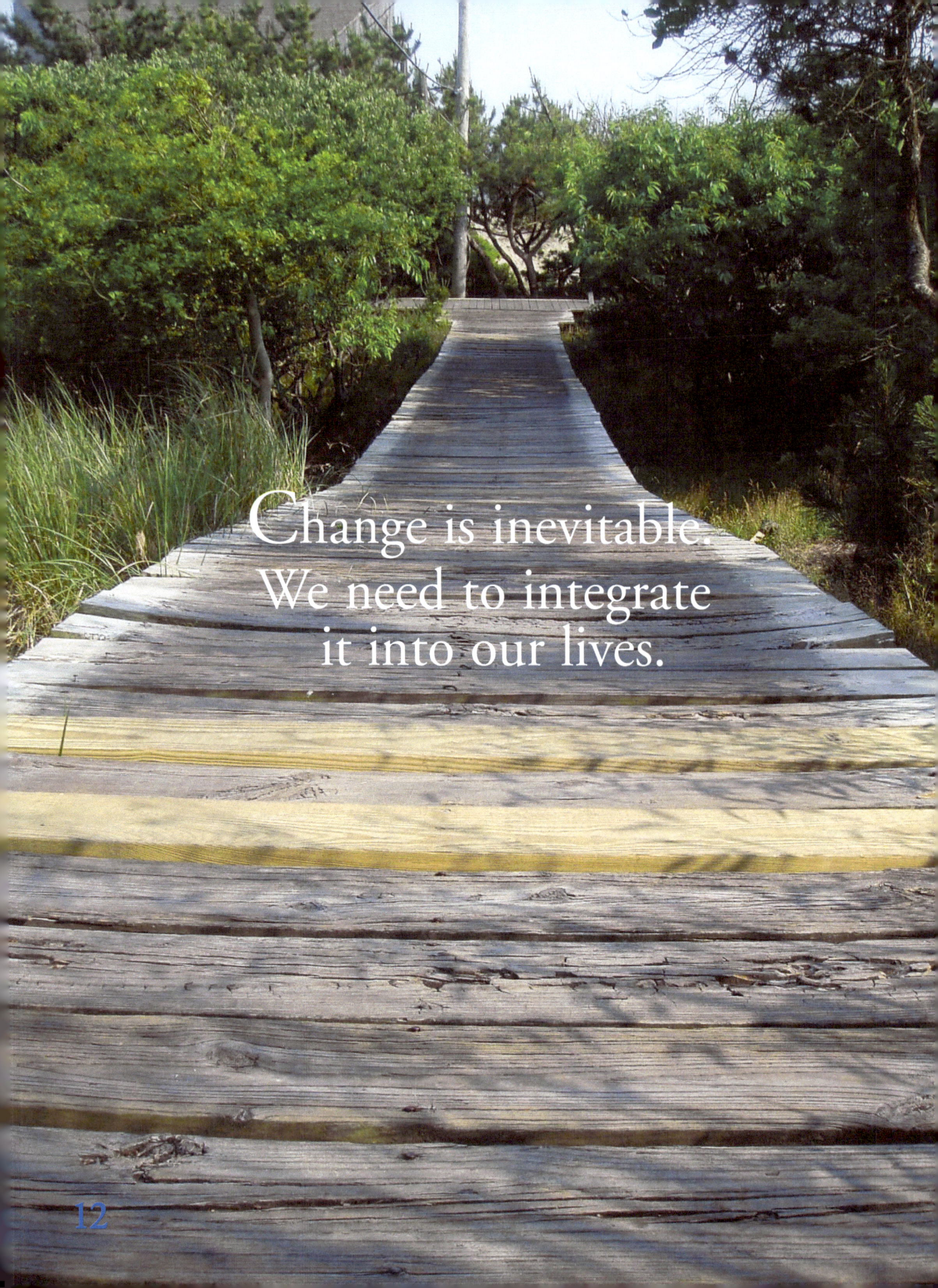

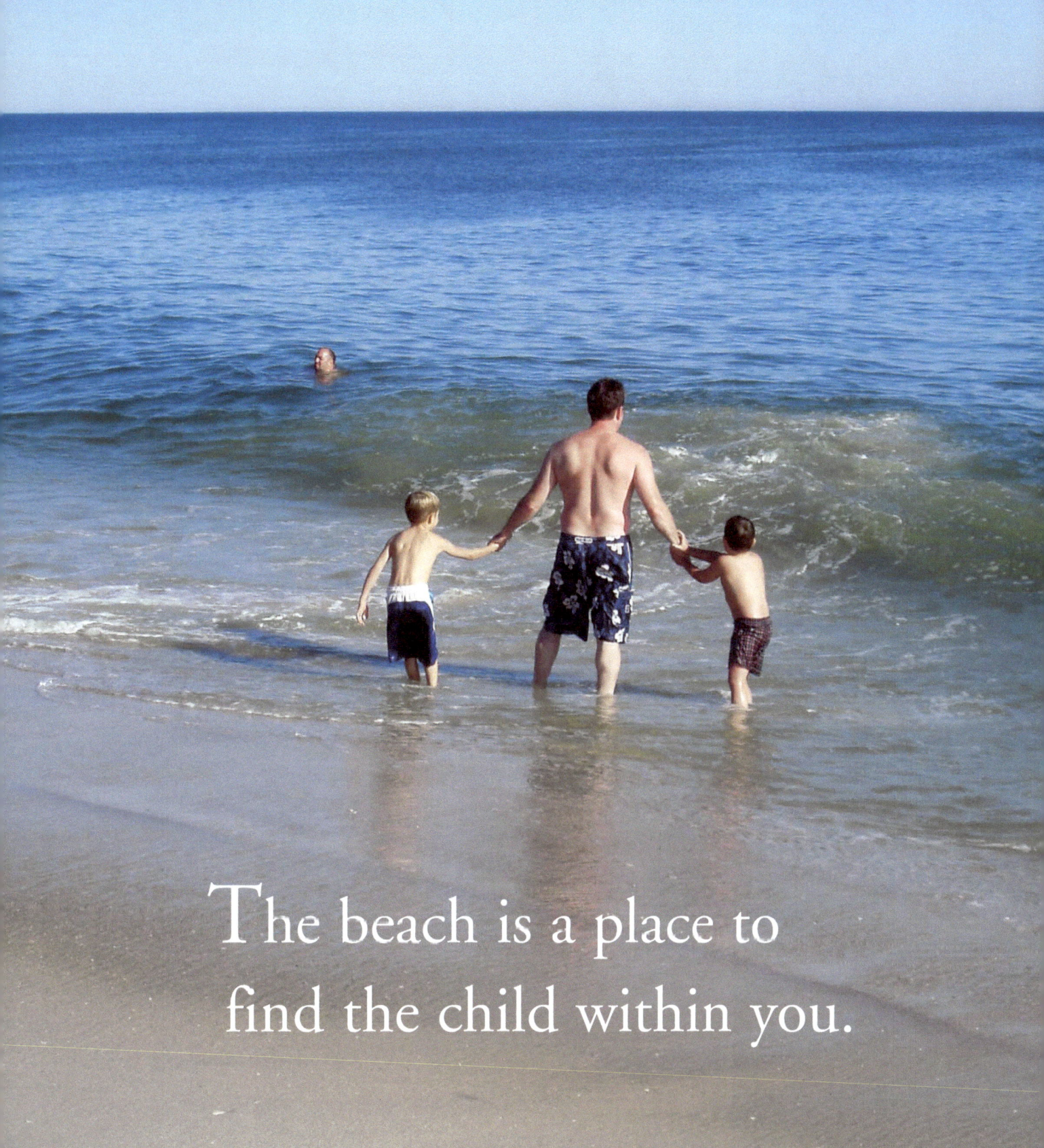

The beach is a place to find the child within you.

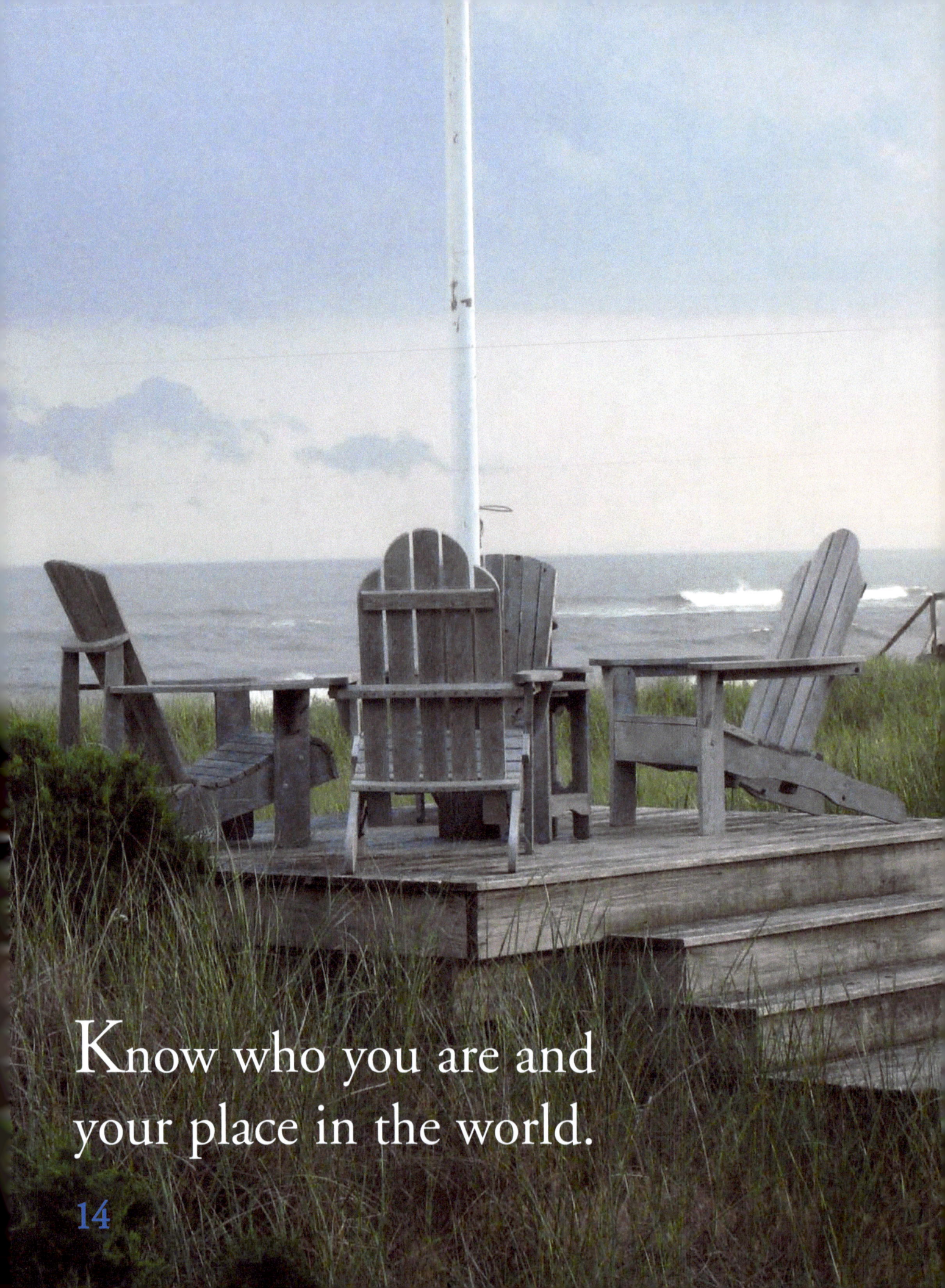

Know who you are and your place in the world.

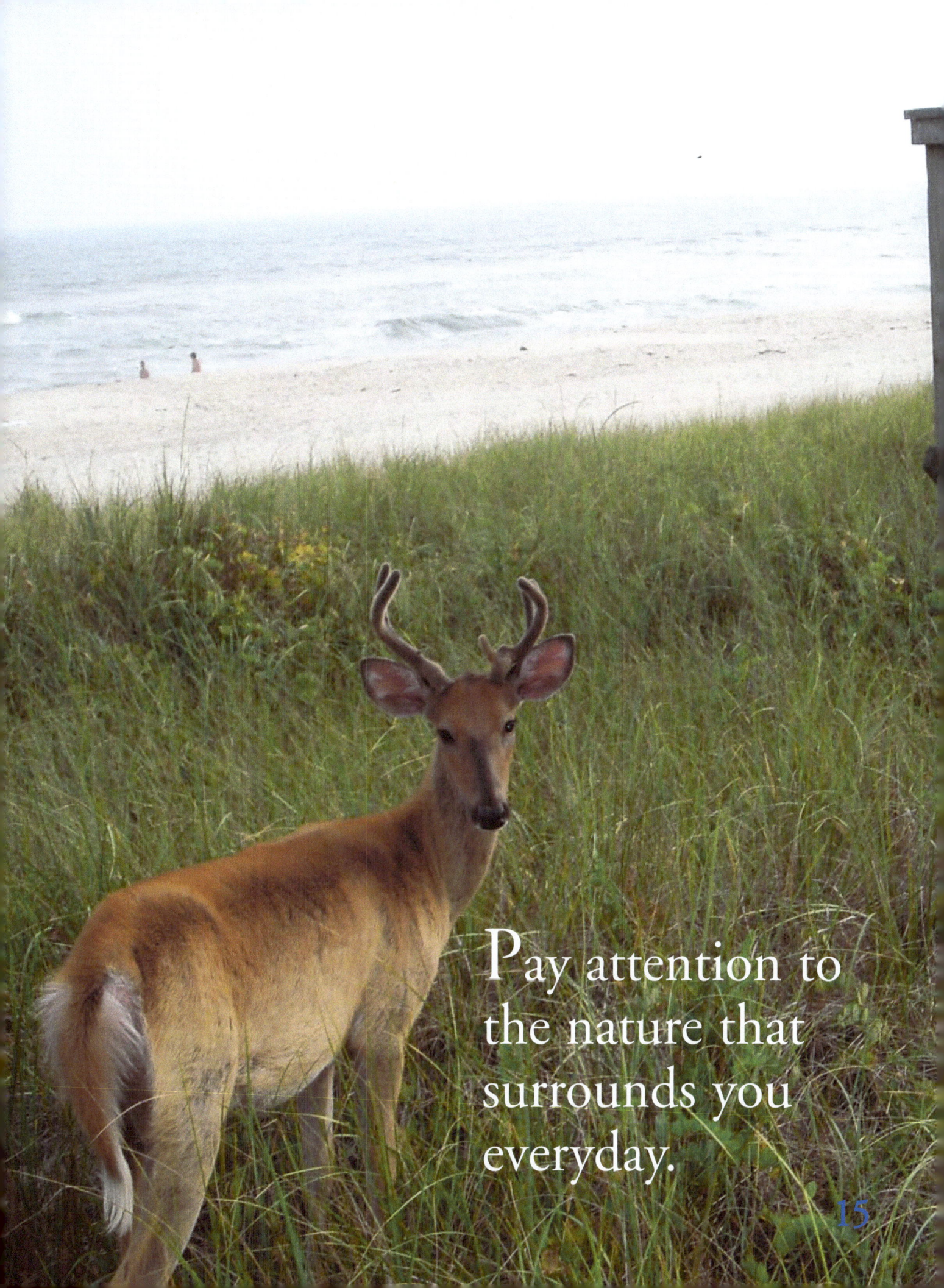

Pay attention to the nature that surrounds you everyday.

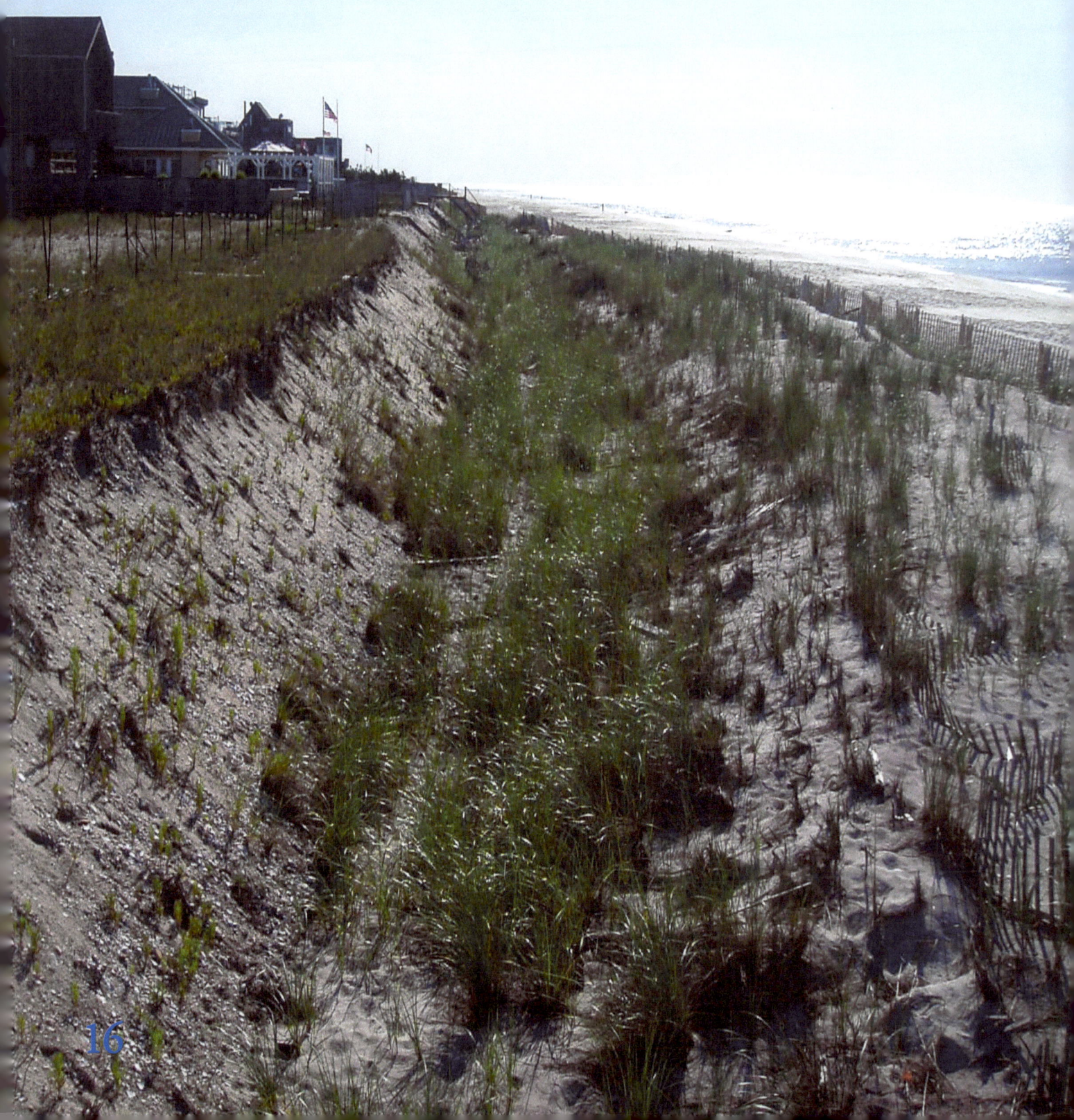

As we rise each morning we must try to be grateful for where we are, and what we have.

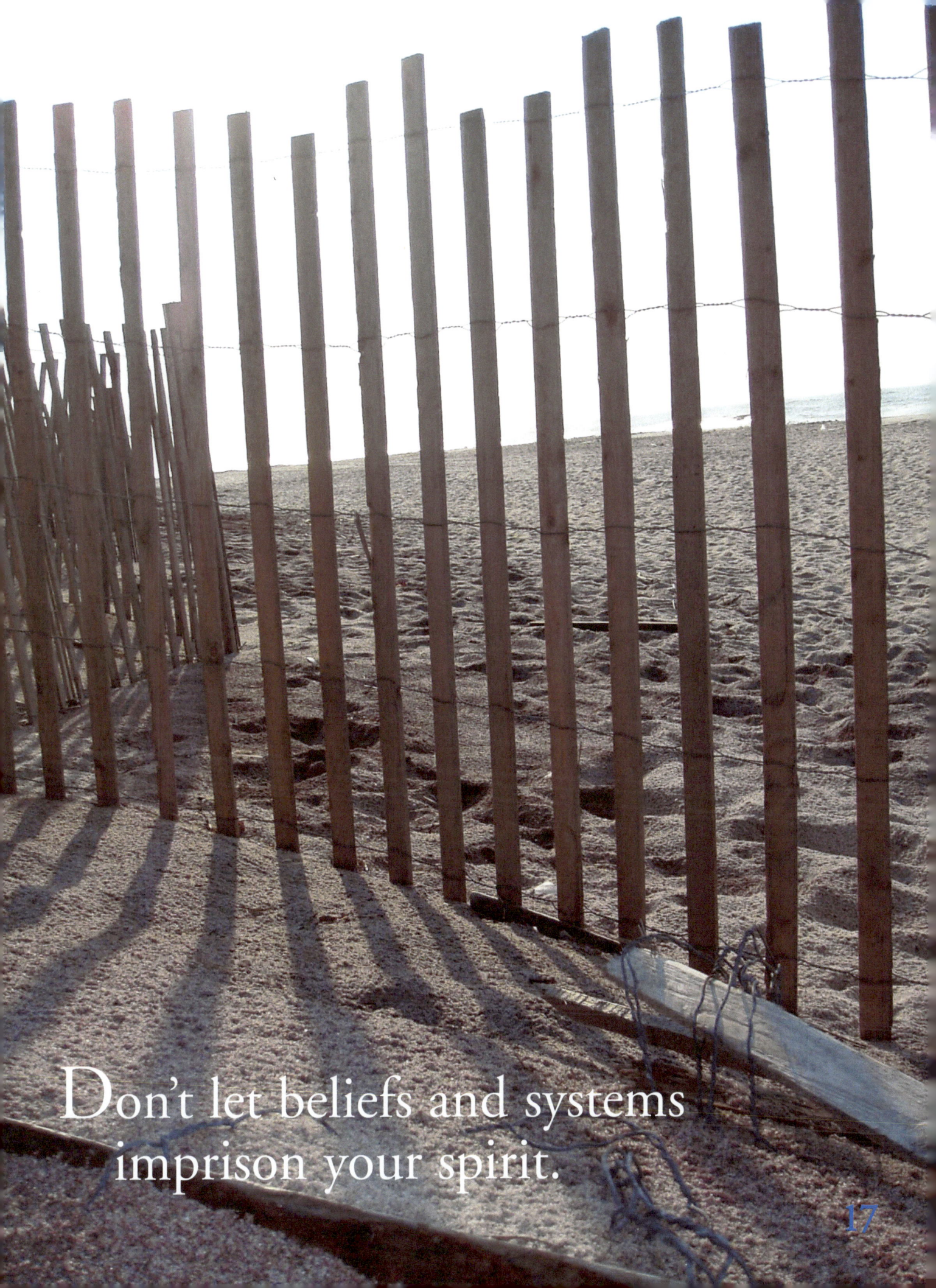

Don't let beliefs and systems imprison your spirit.

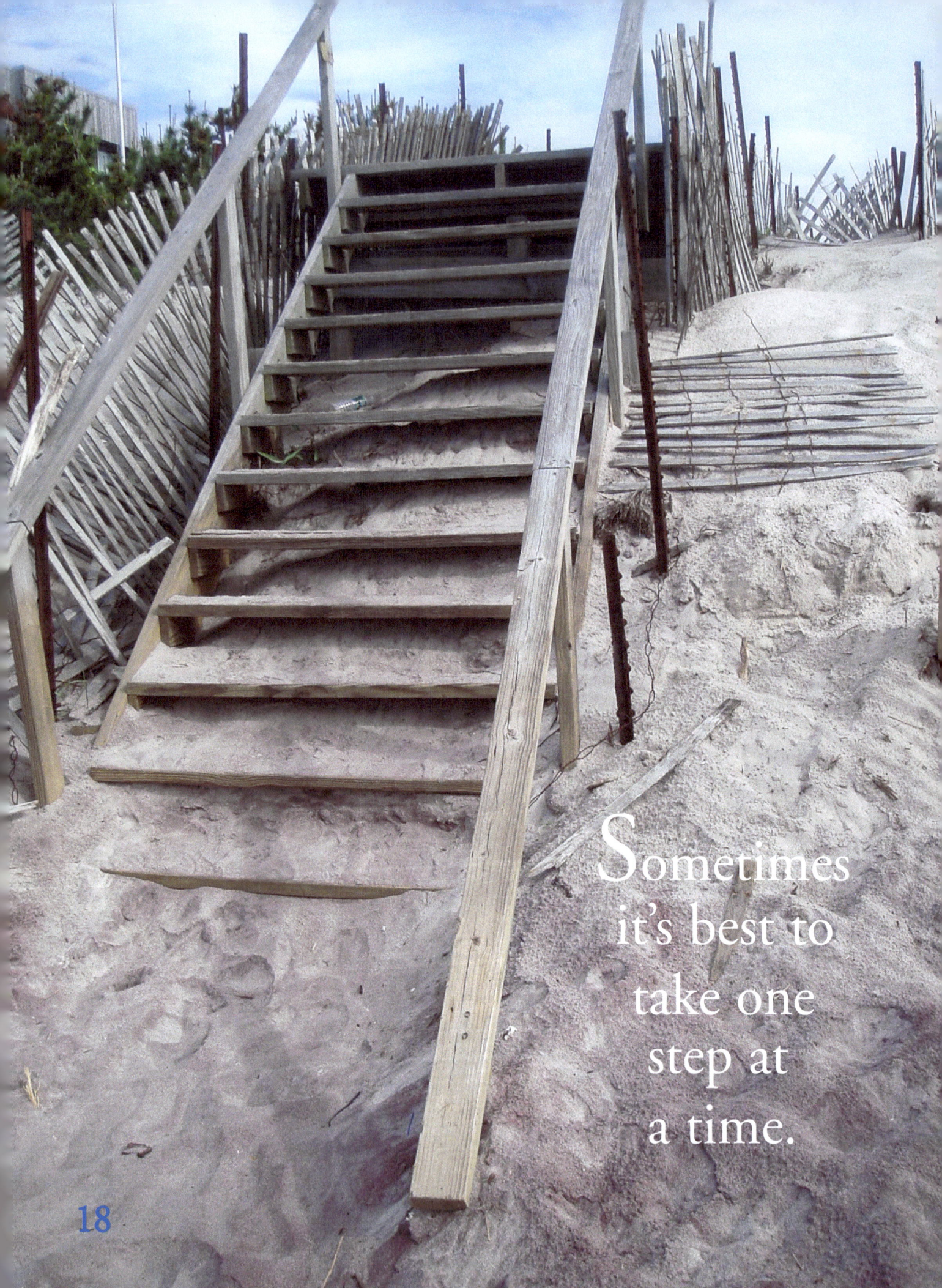

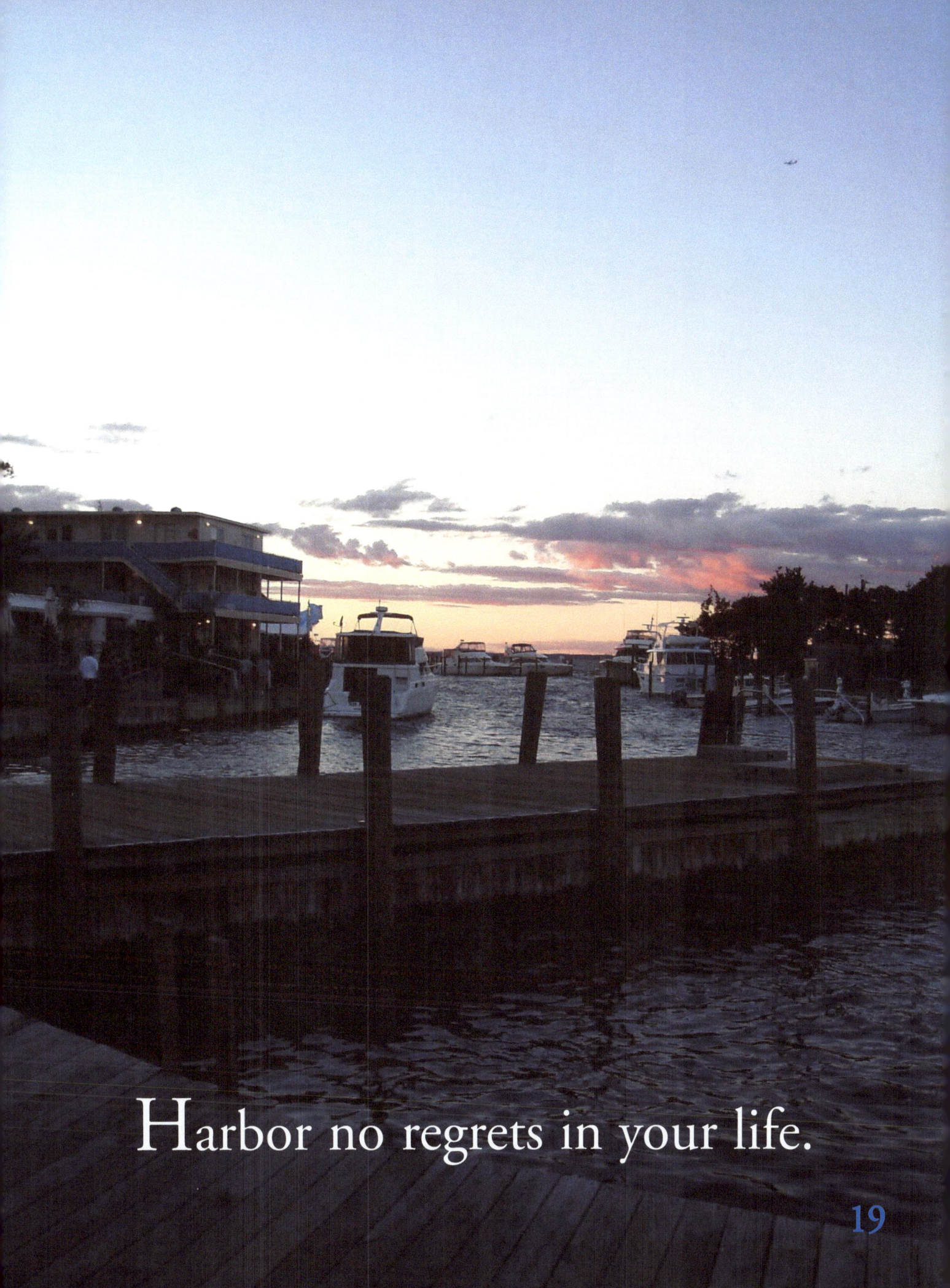

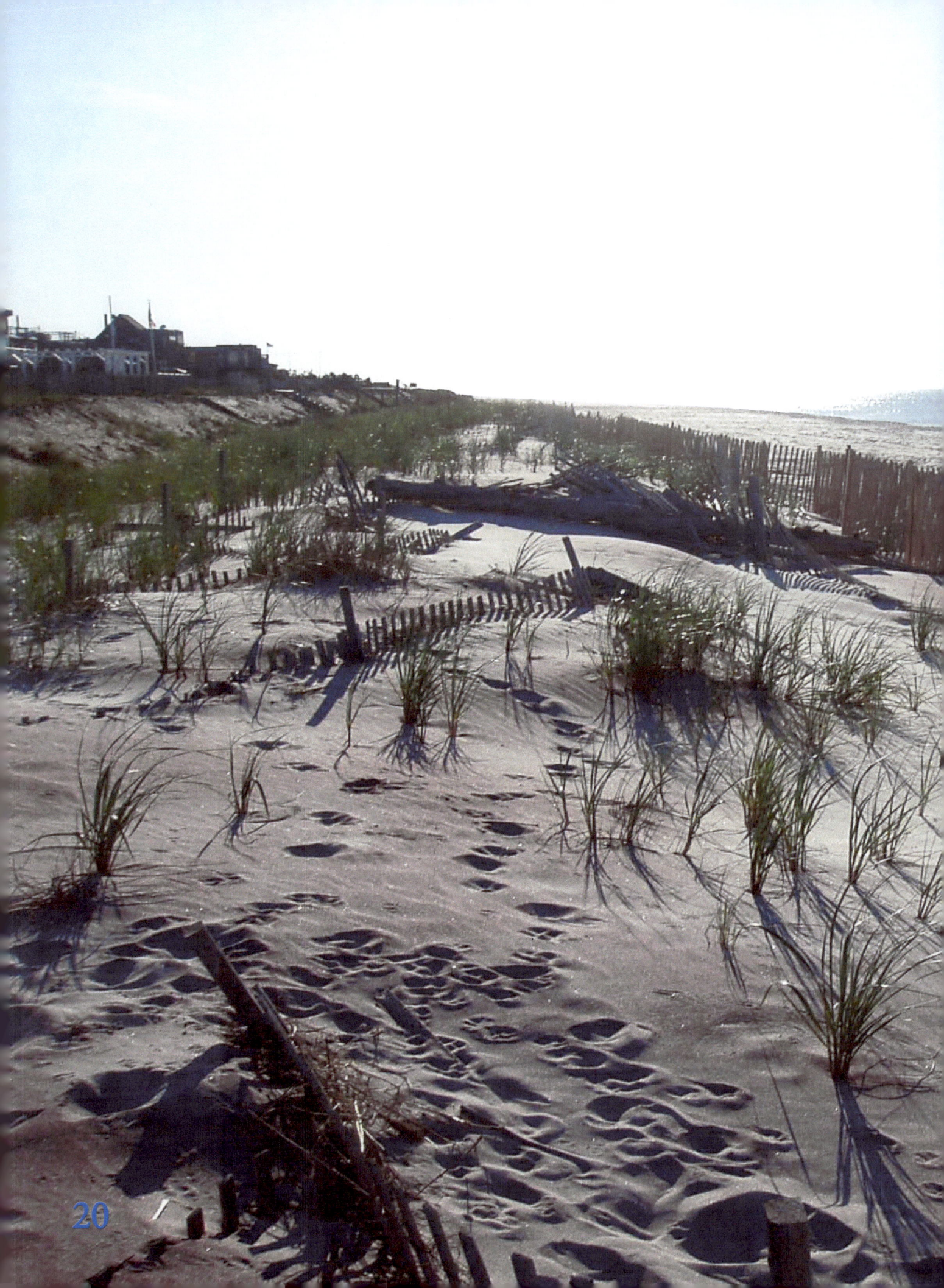

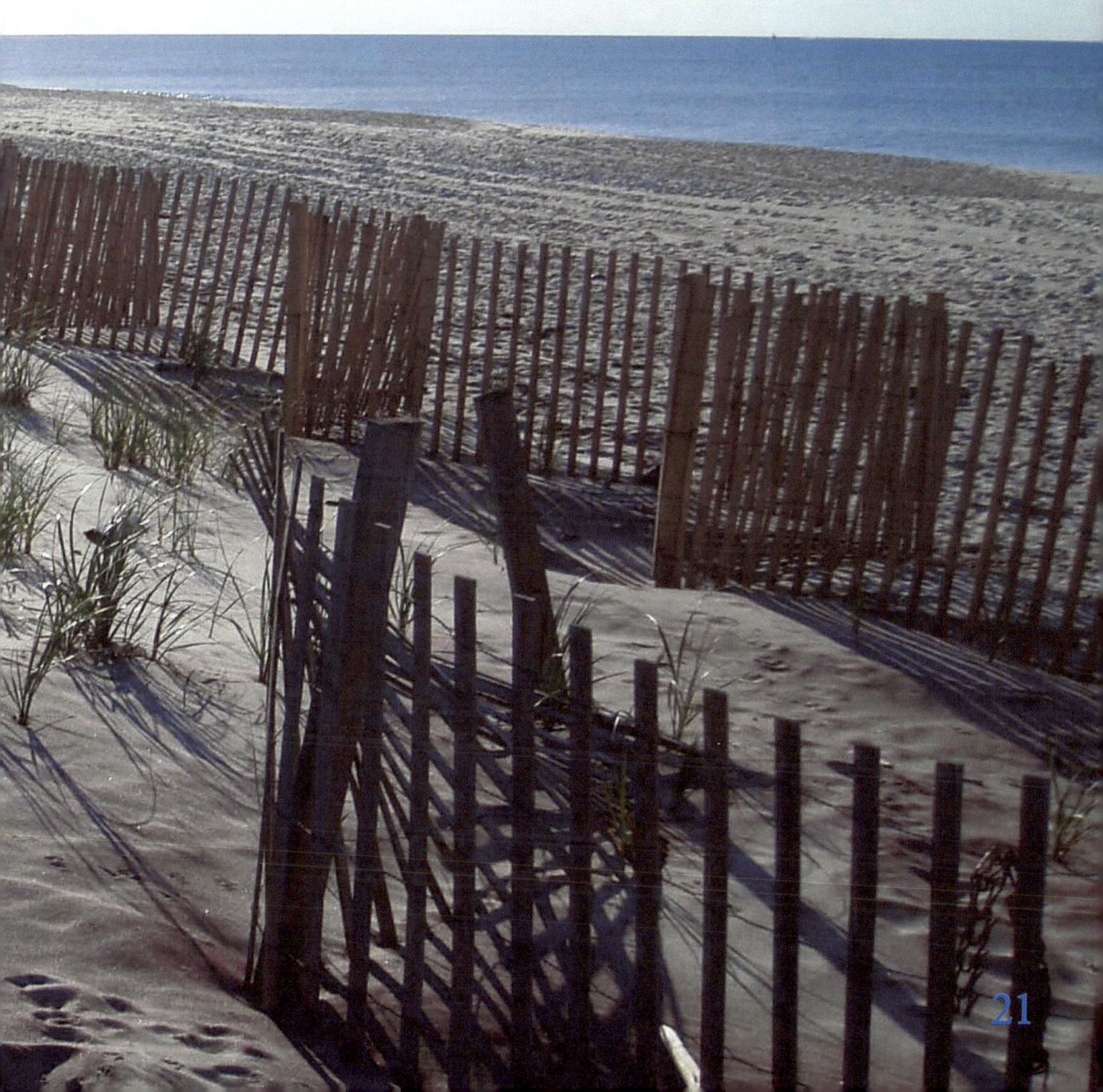

Try to start your day with peaceful thoughts.

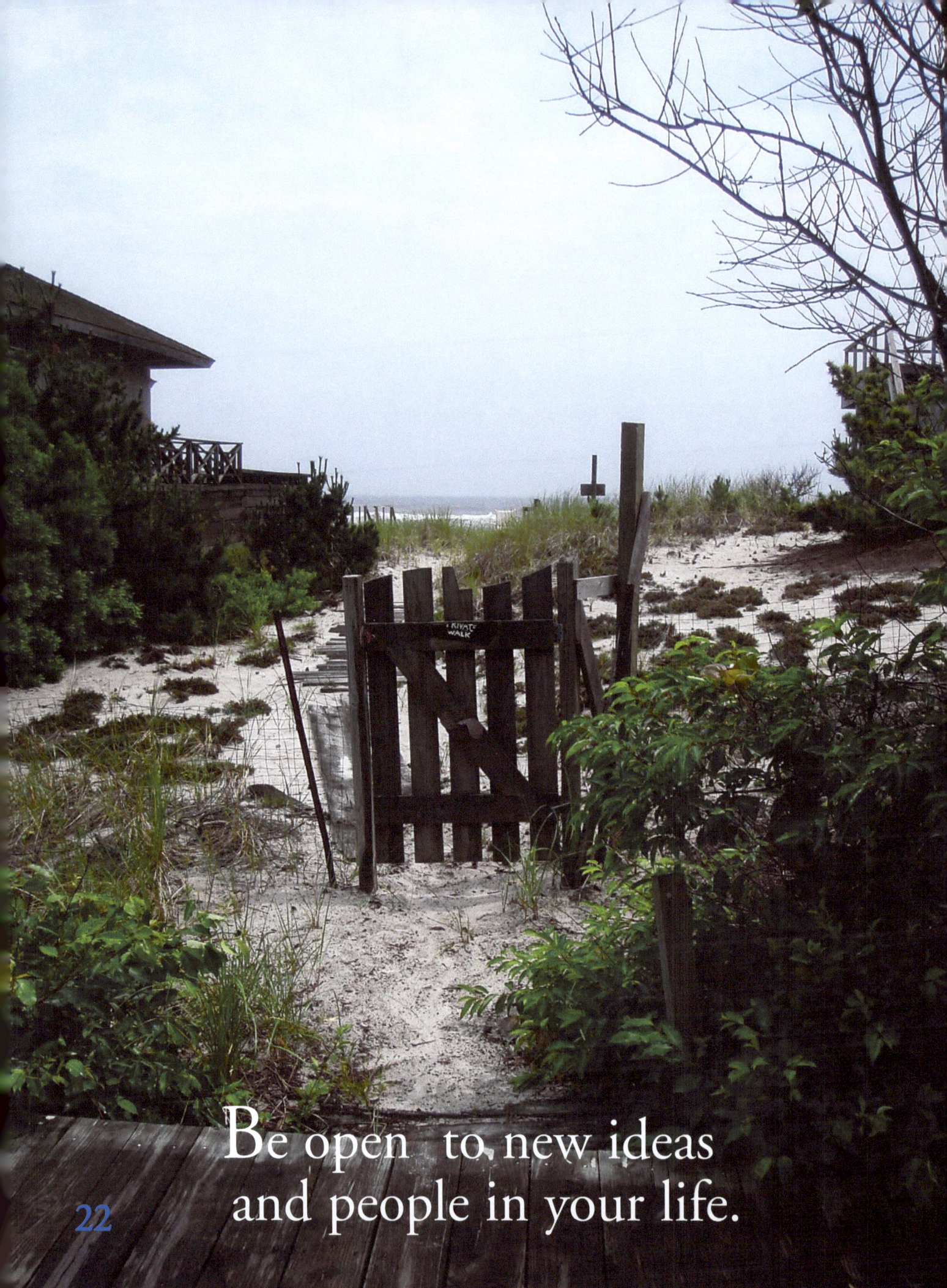

Be open to new ideas and people in your life.

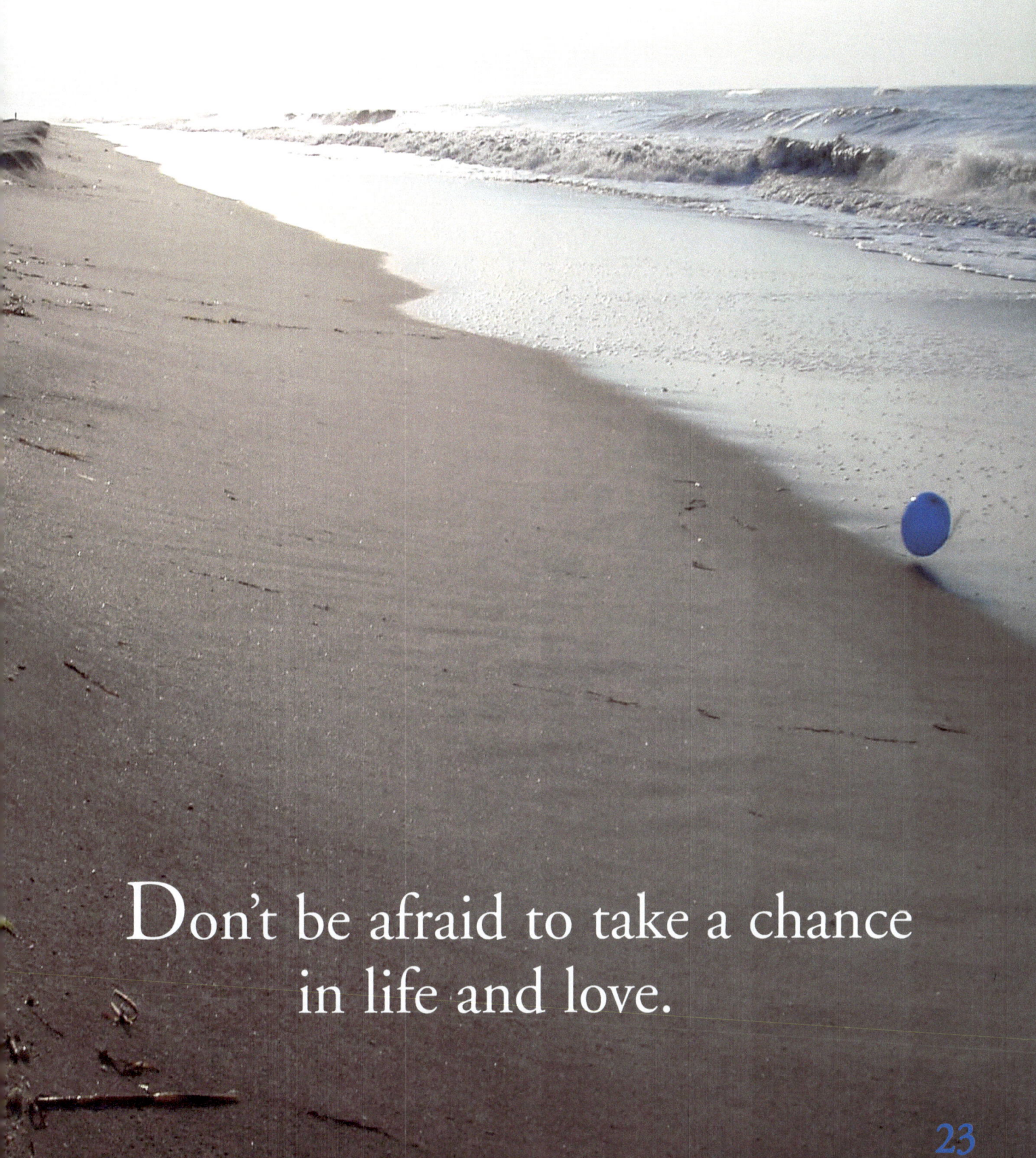

Don't be afraid to take a chance in life and love.

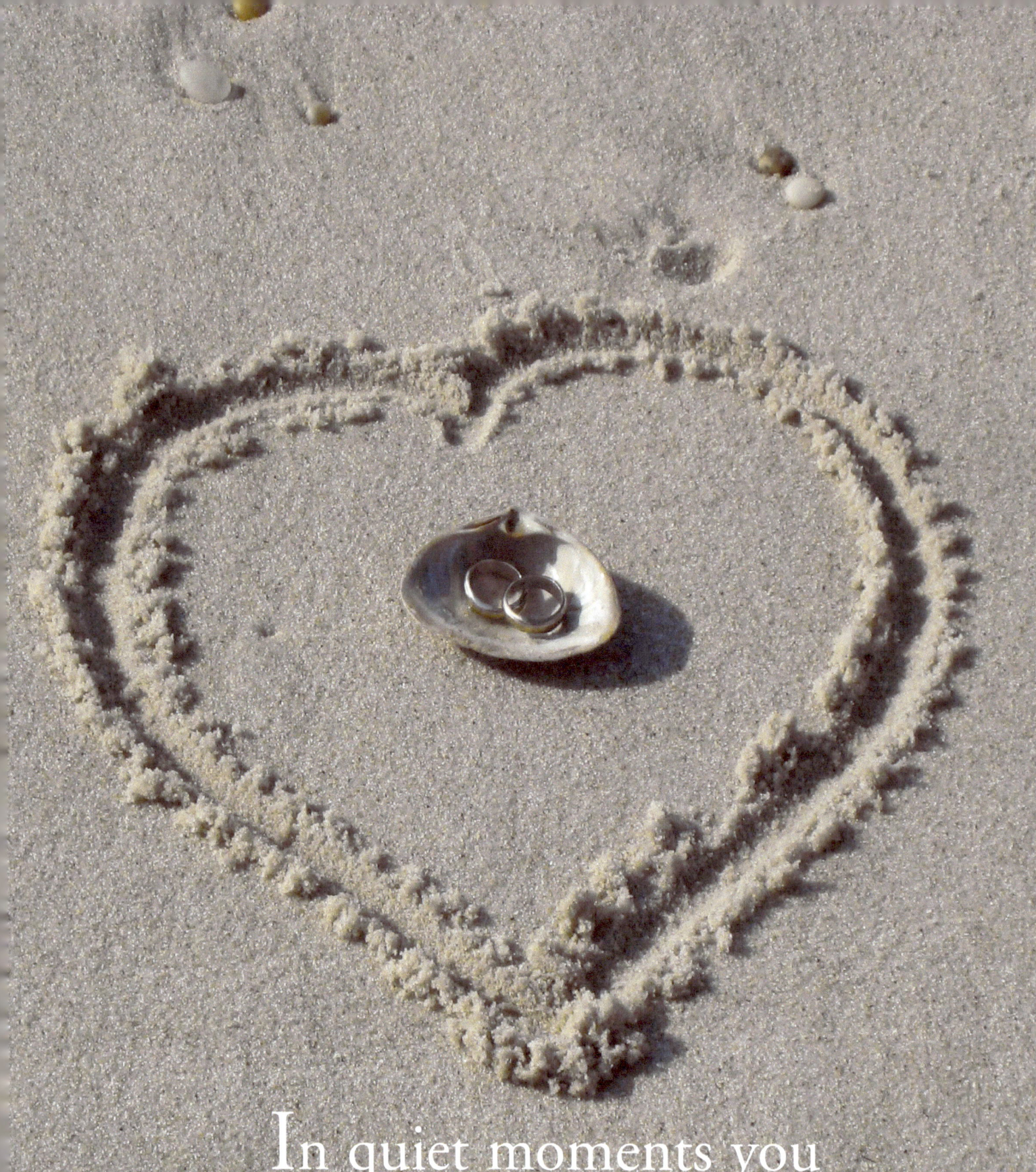

In quiet moments you don't need words.

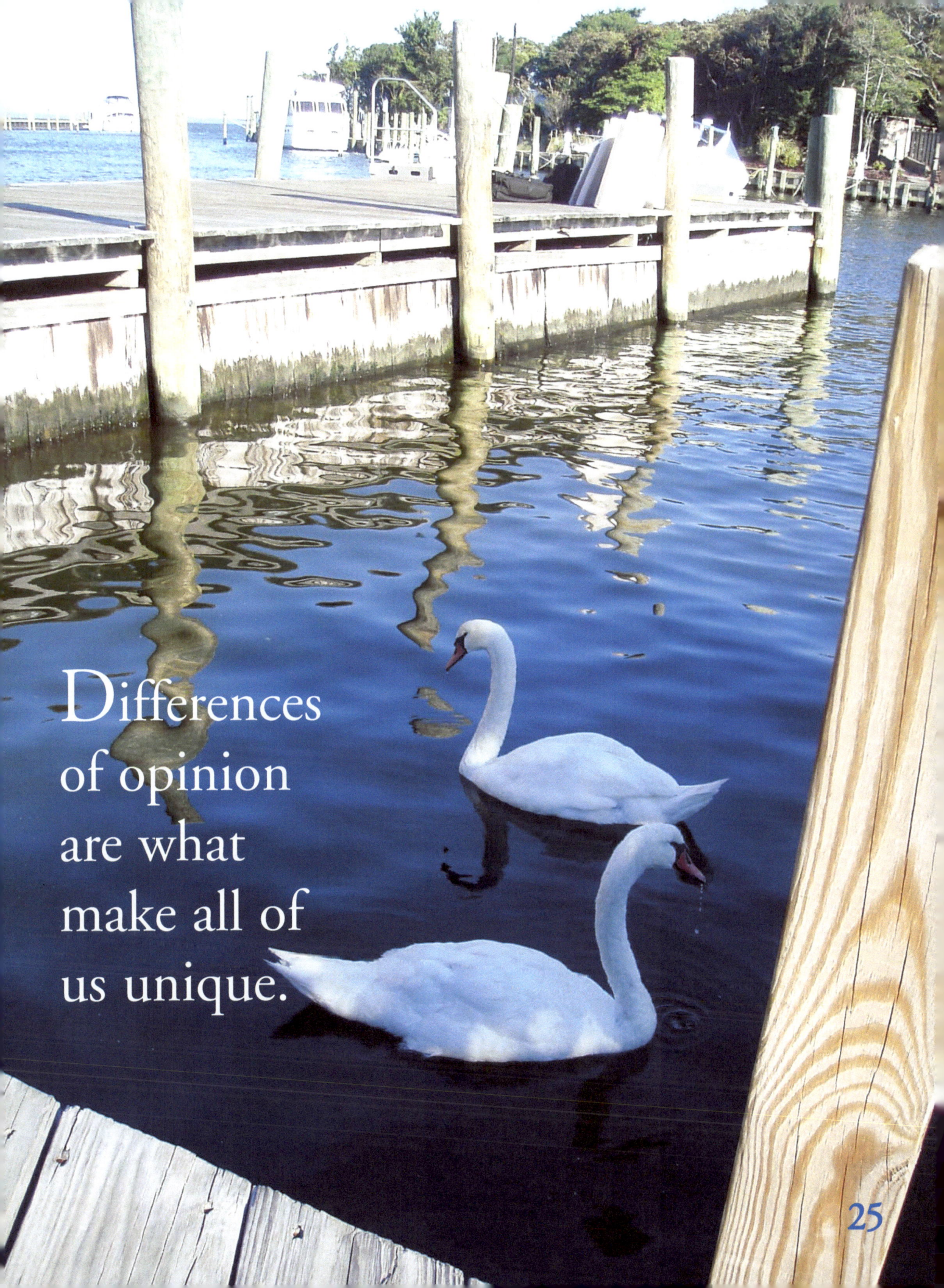

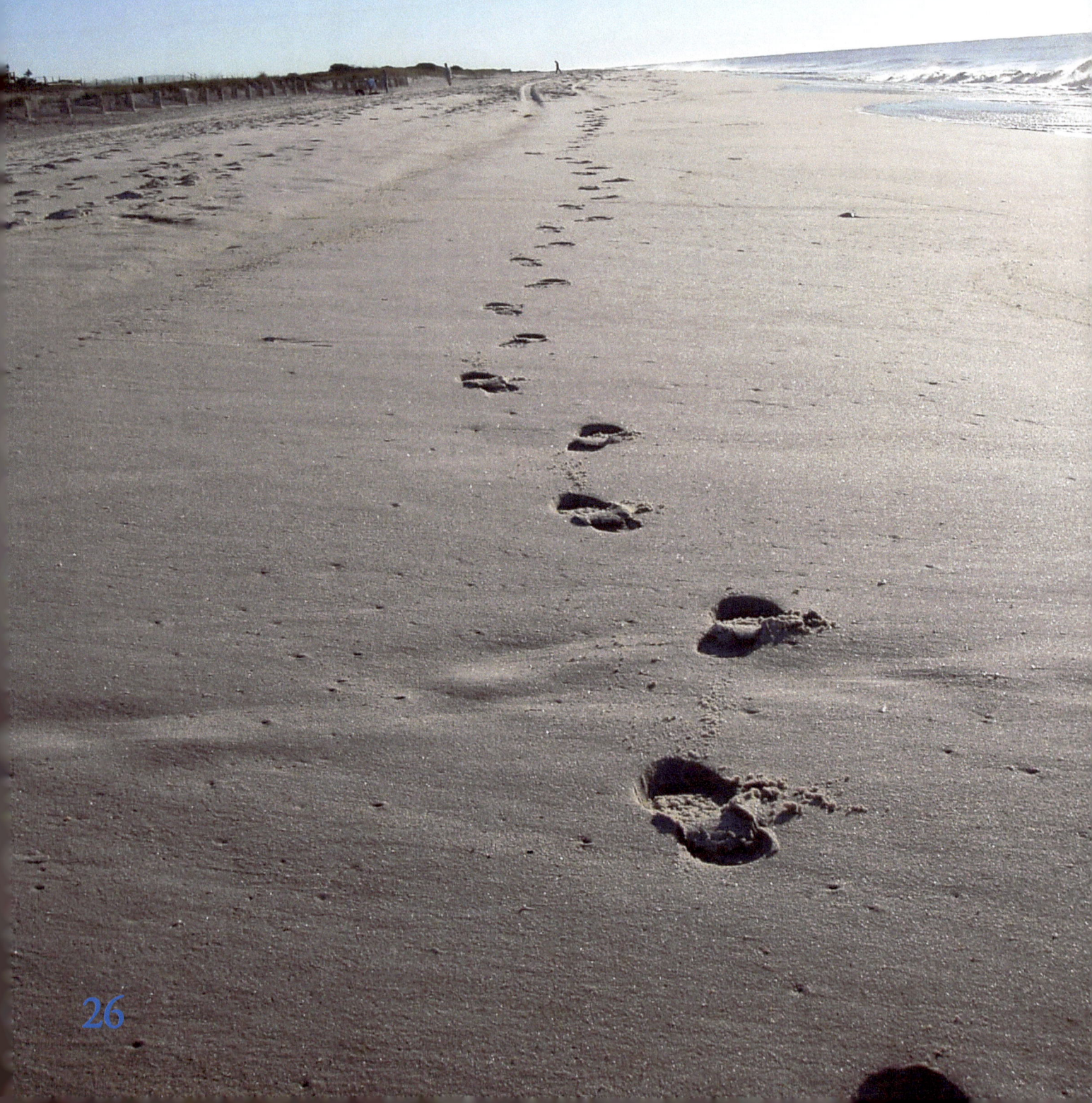

The beach is a place to be alone with your thoughts.

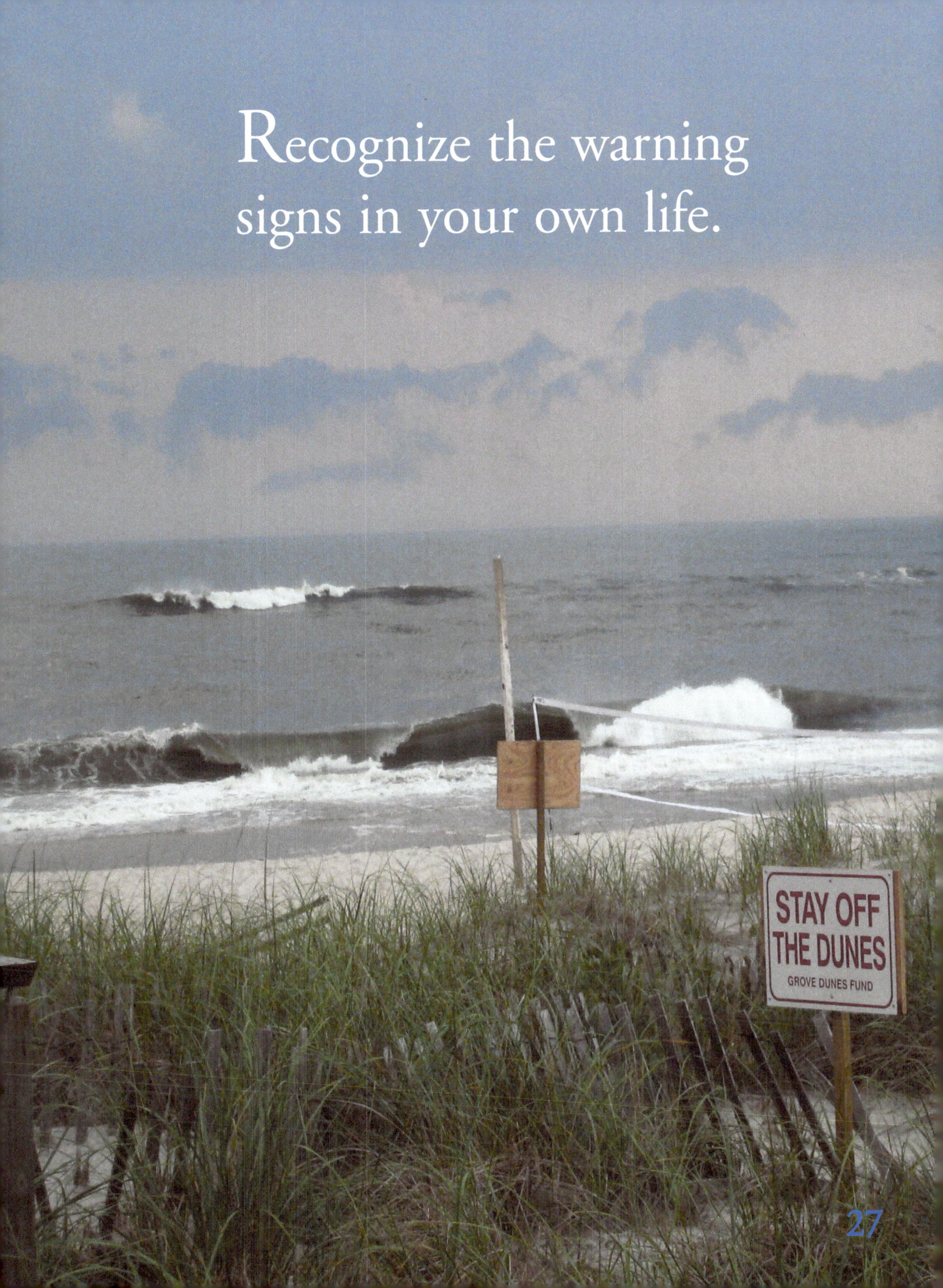
Recognize the warning signs in your own life.

We create the situations, and relationships that litter our lives.

Don't let the barriers and walls you surround yourself with keep people from knowing the real you.

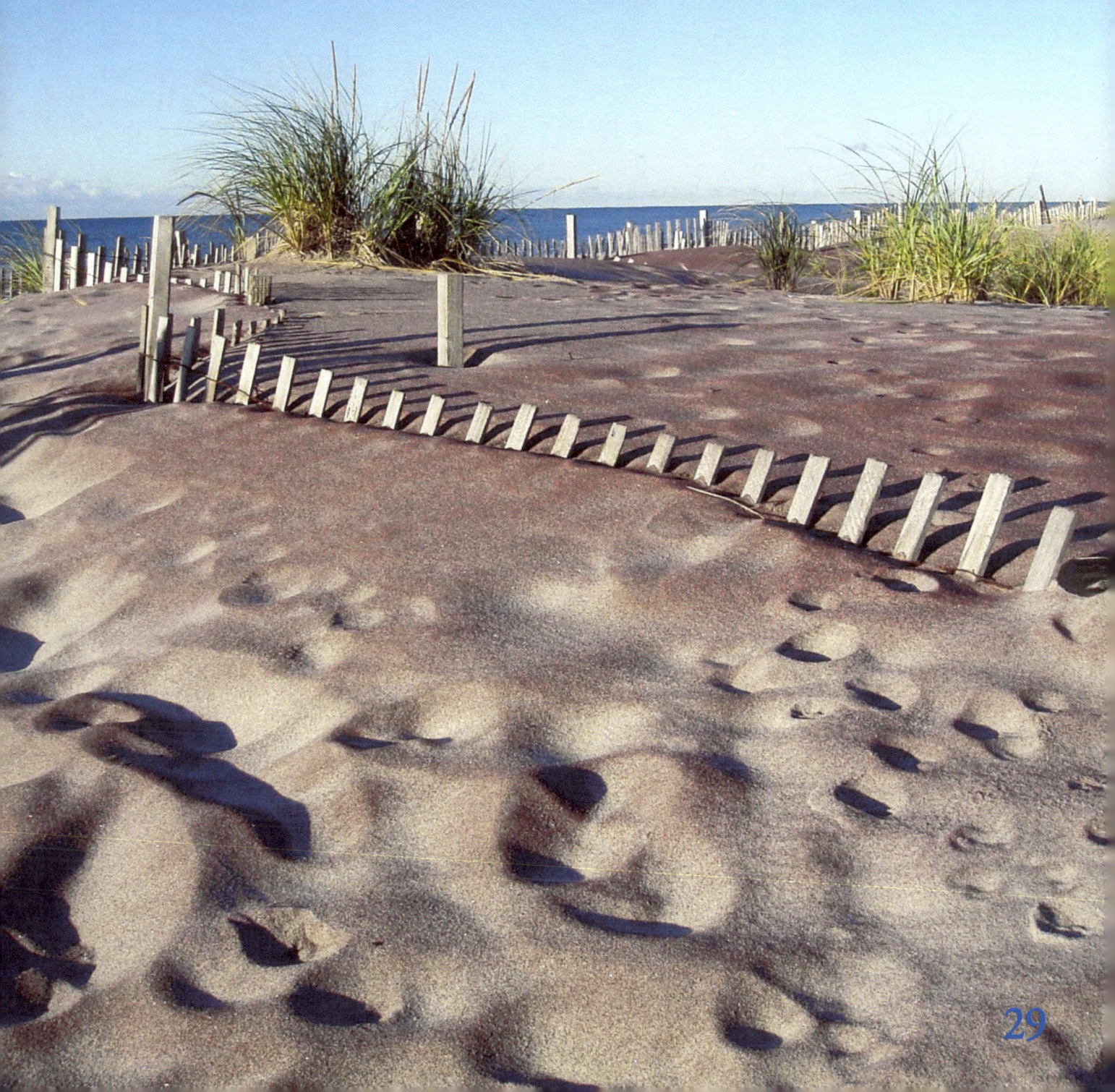

There is always light even in the darkest moments.

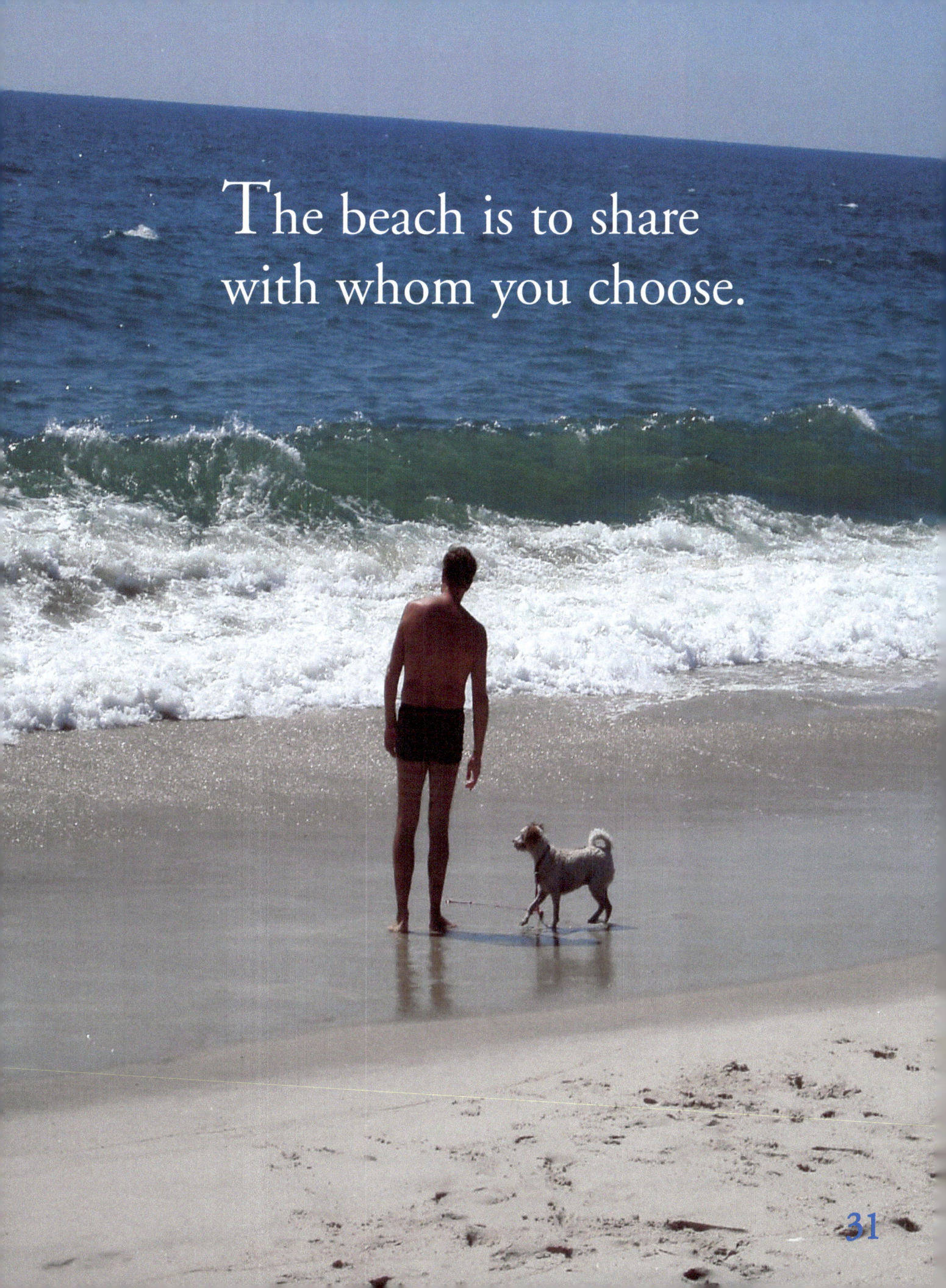

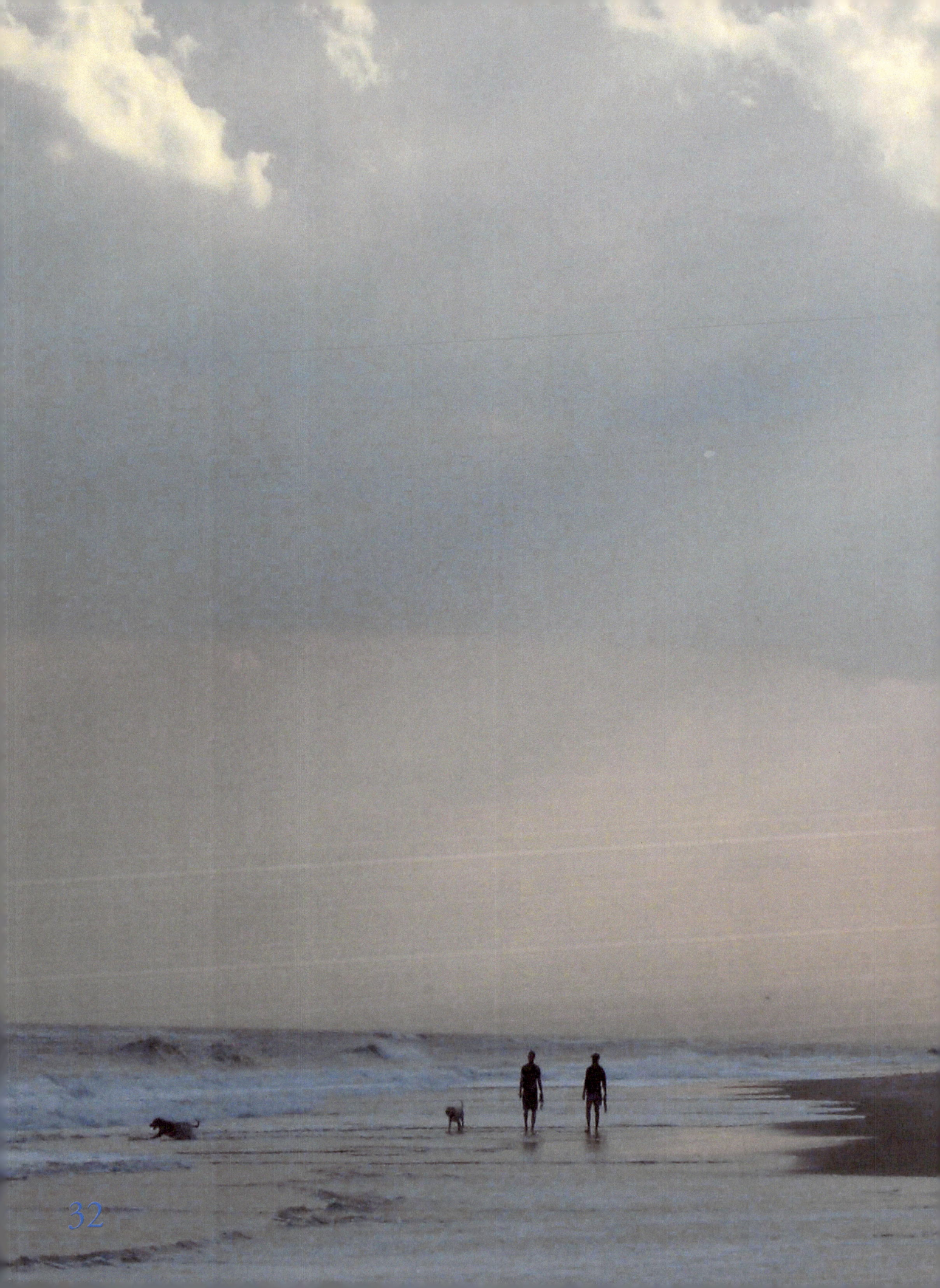

Sometimes nothing to do is a good thing.

In a world that shouts conformity celebrate the difference that is you!

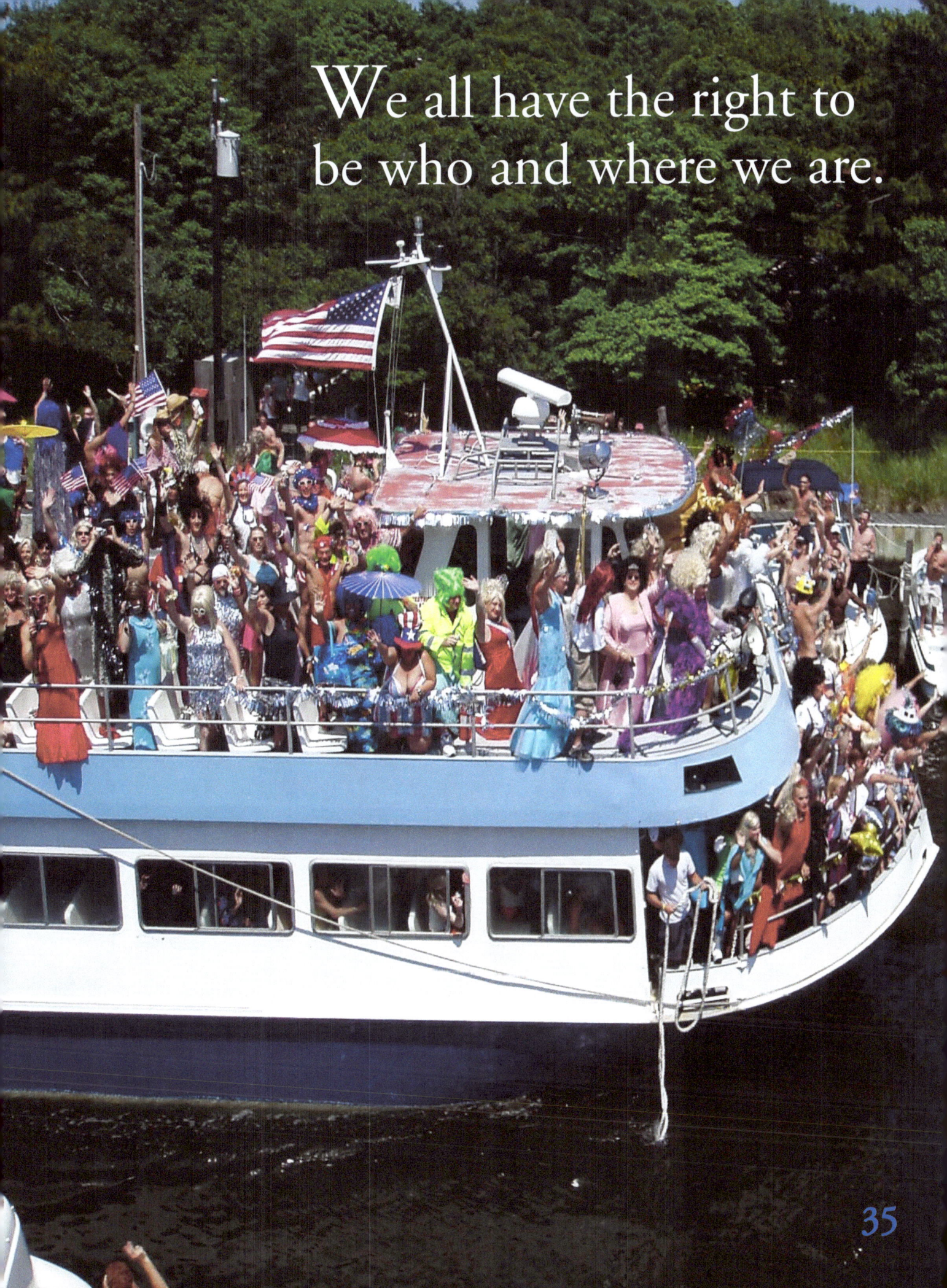
We all have the right to be who and where we are.

Judgments and opinions can tangle and mire your view of the world.

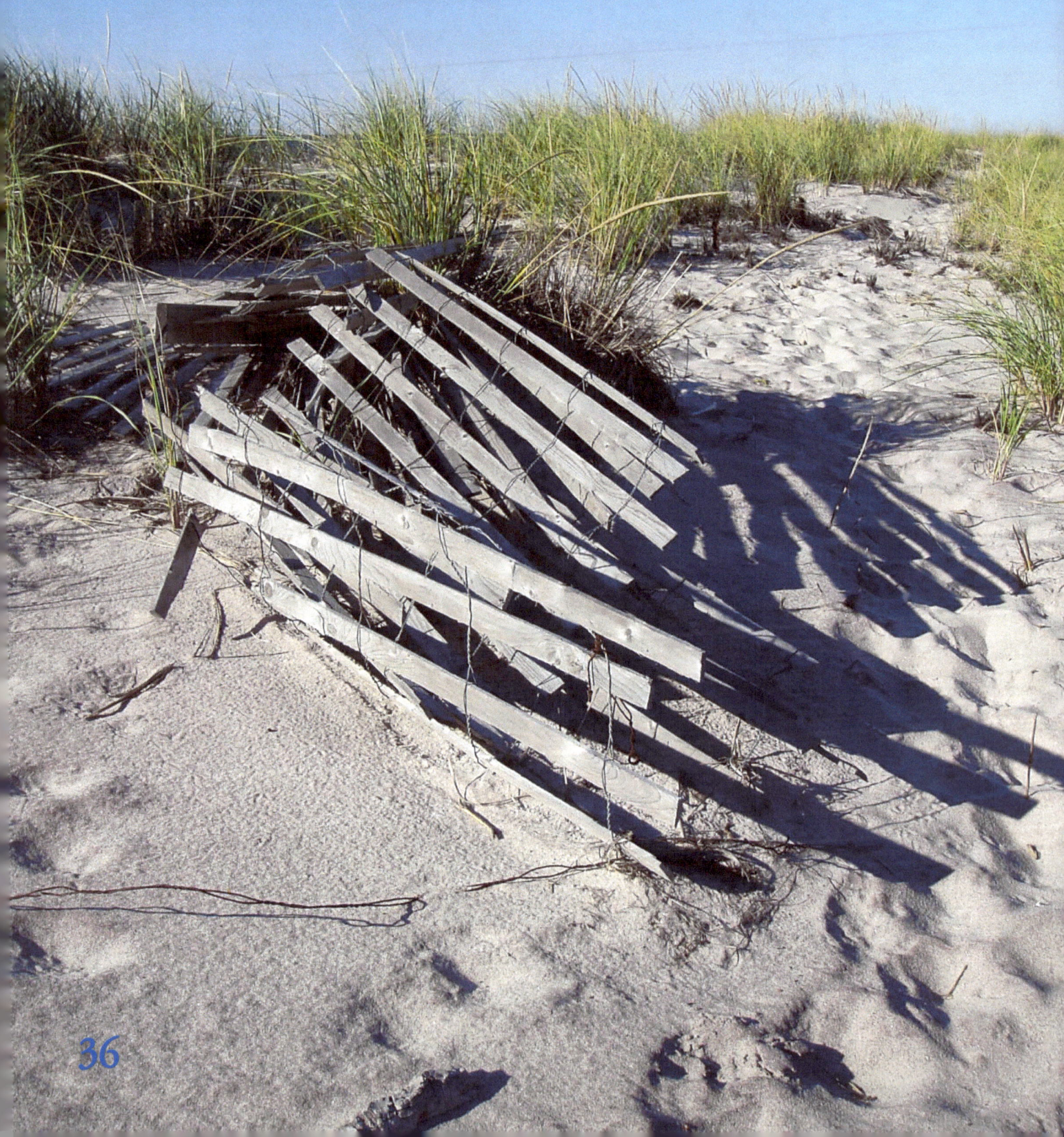

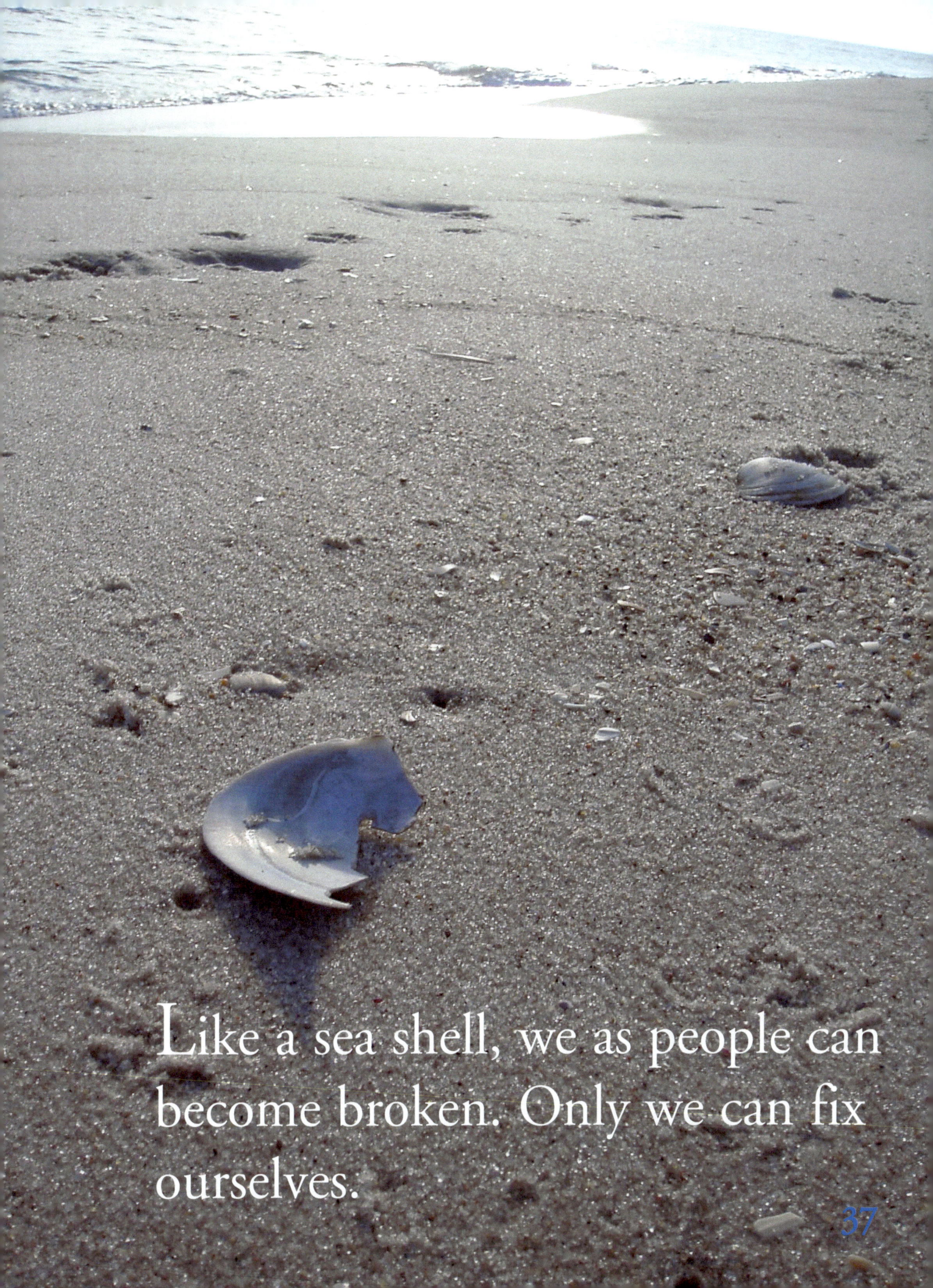
Like a sea shell, we as people can become broken. Only we can fix ourselves.

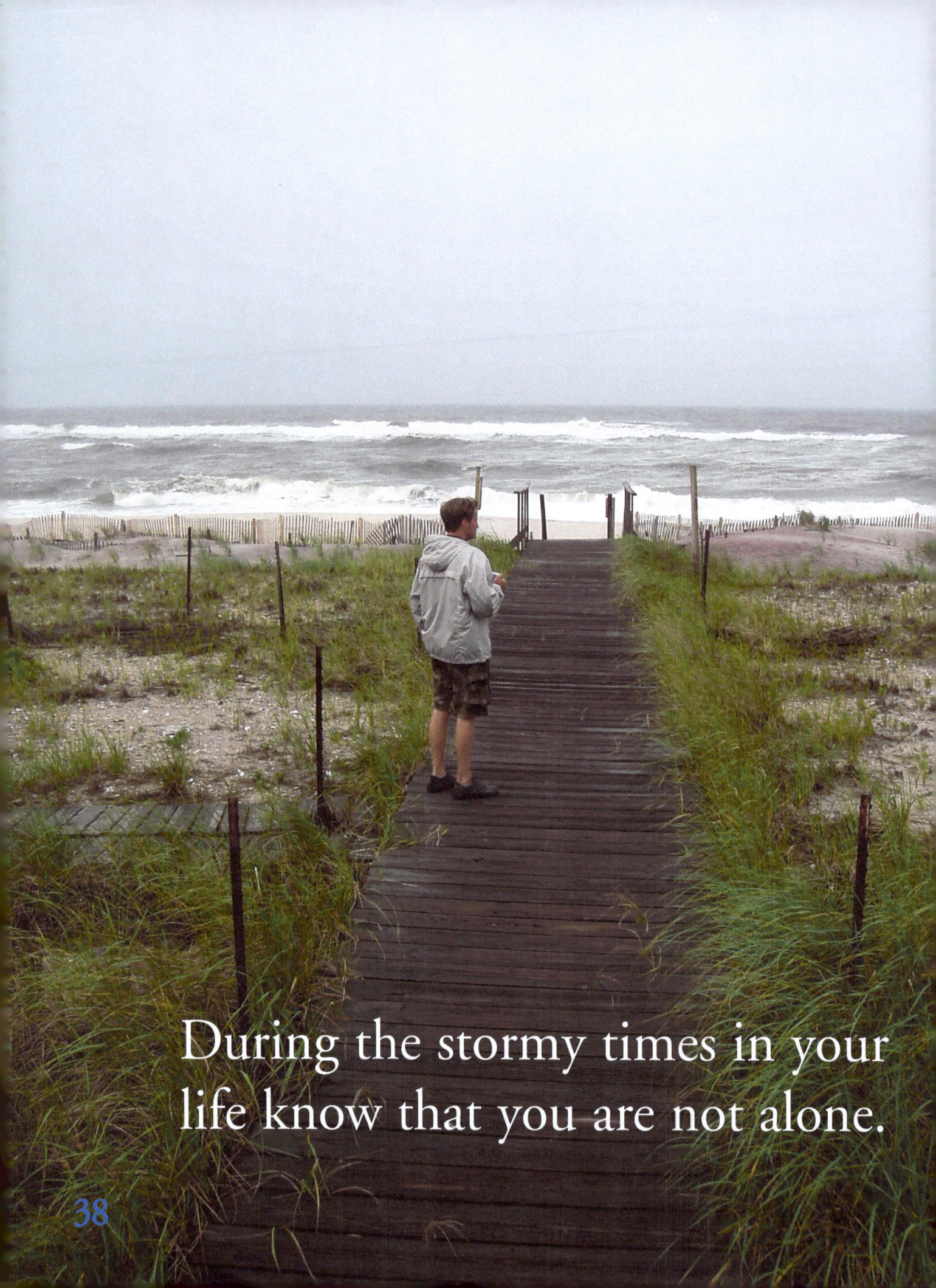
During the stormy times in your life know that you are not alone.

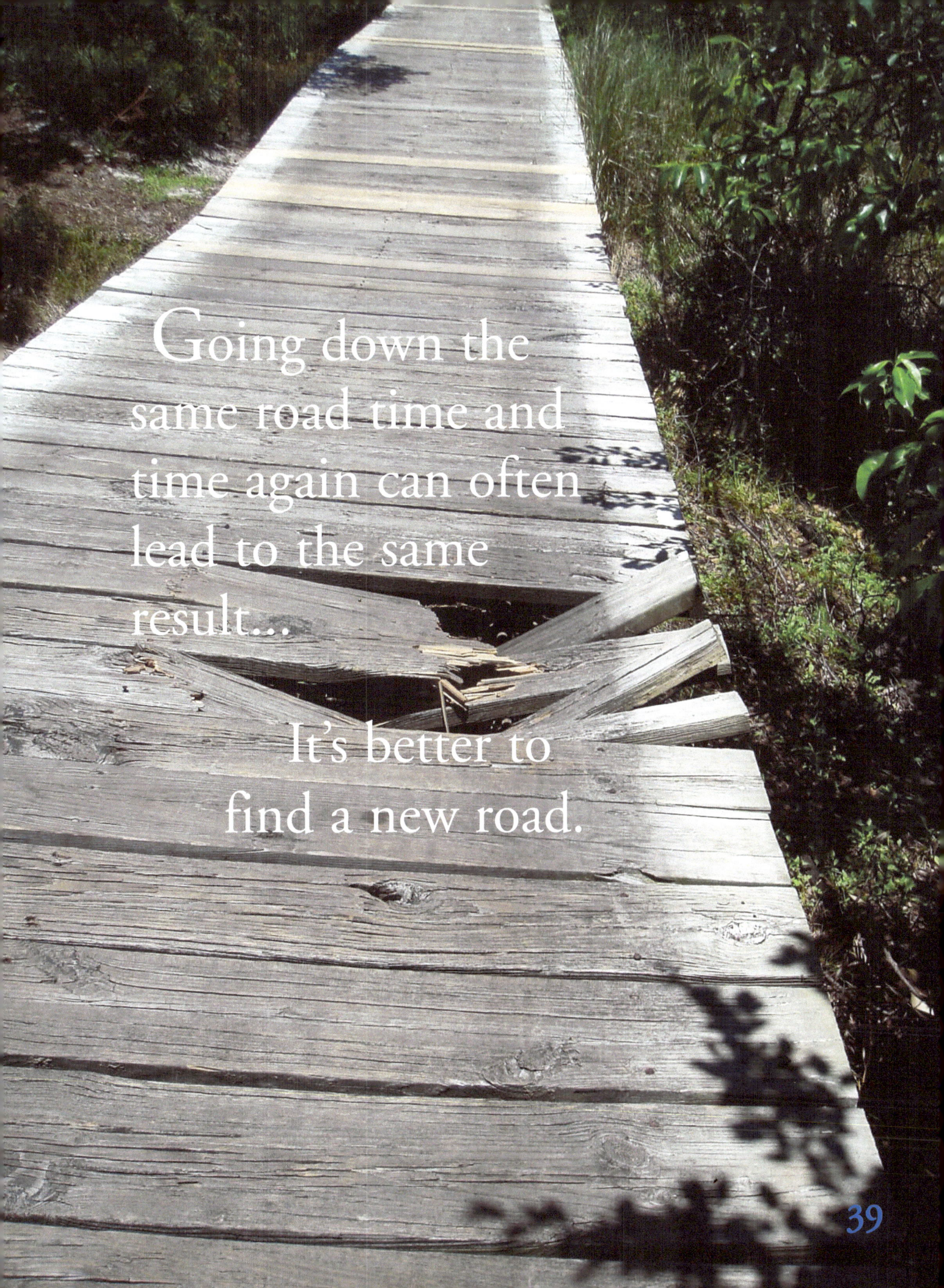

Going down the same road time and time again can often lead to the same result...

It's better to find a new road.

Don't let your insecurities hide your true feelings when there is an opportunity for love.

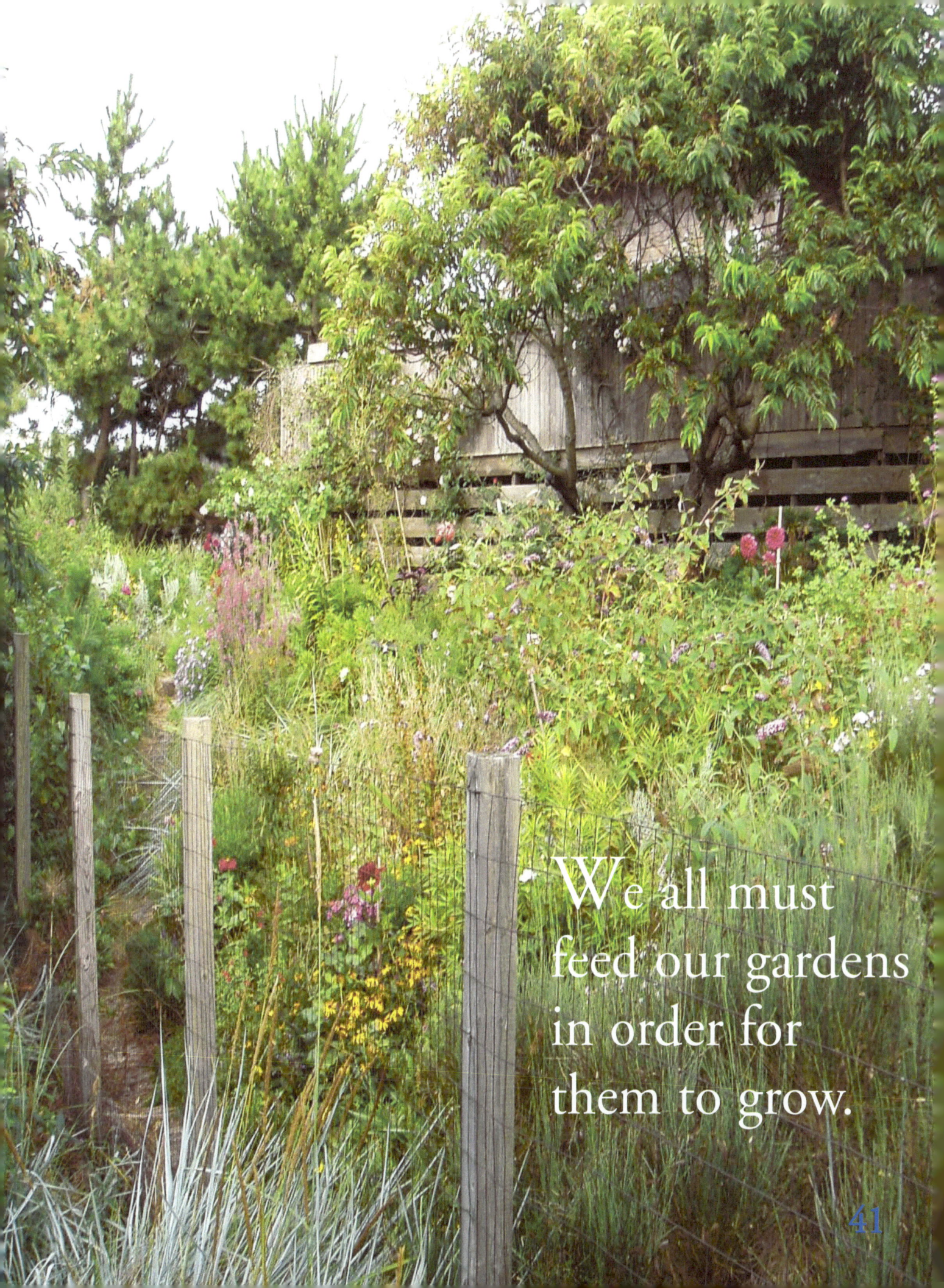

We all must feed our gardens in order for them to grow.

No matter how blue you get, if you look there is always a bright spot.

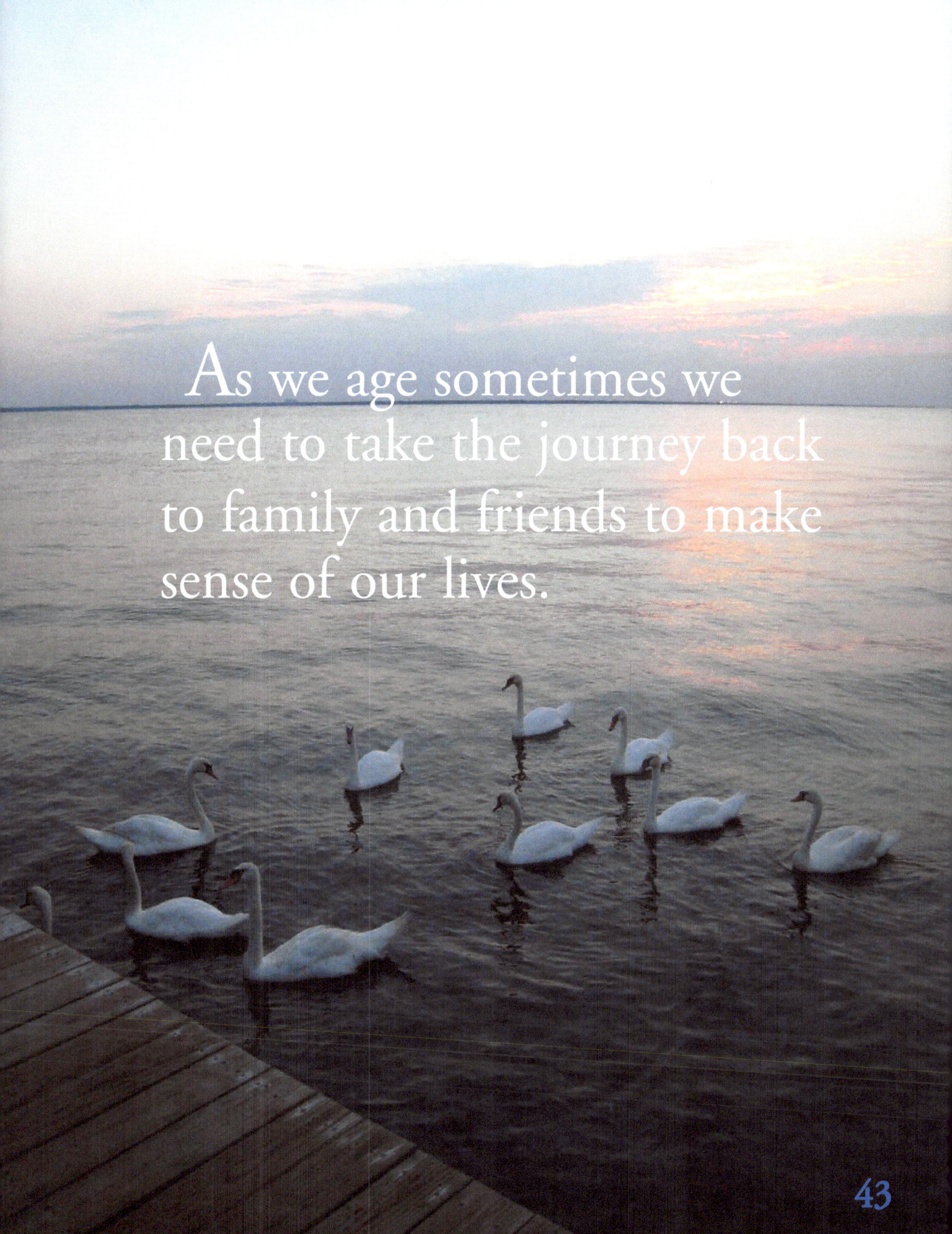

When the day is over take the time to stand still and just be.

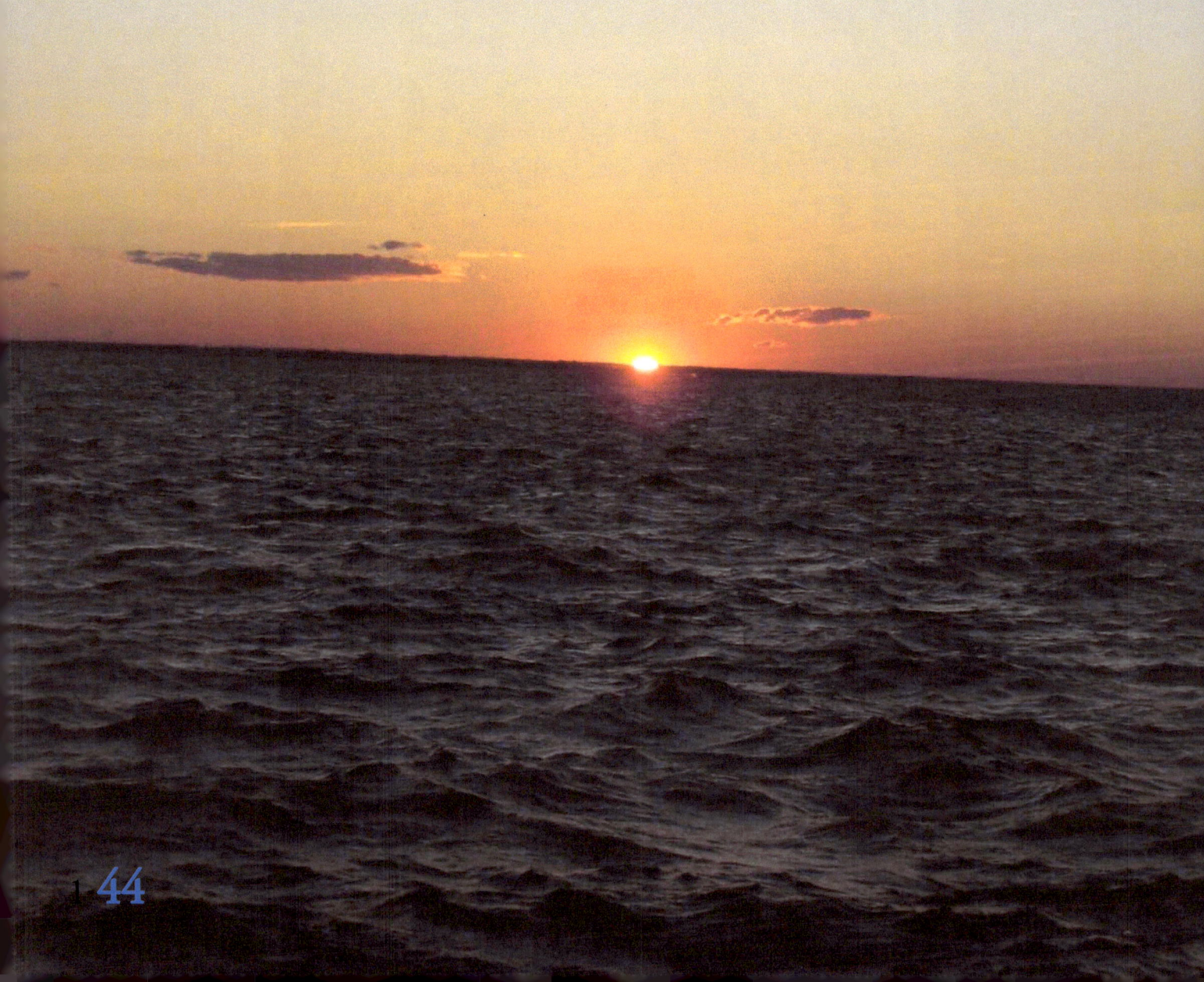

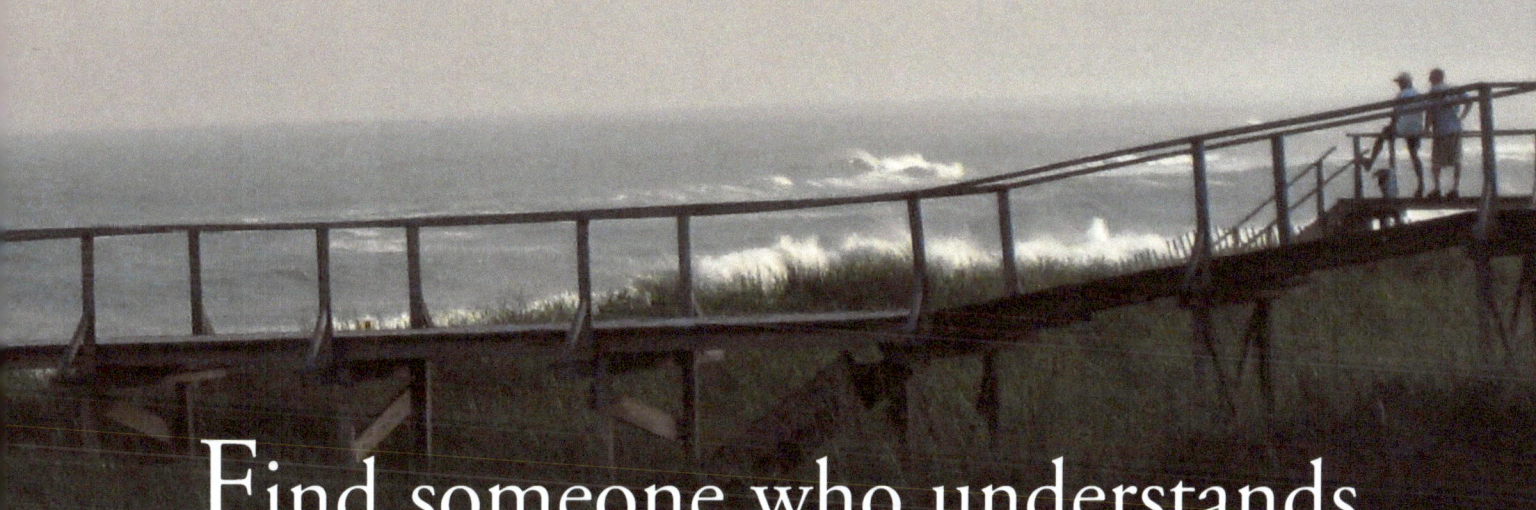

Find someone who understands you and your view of the world to share the journey.

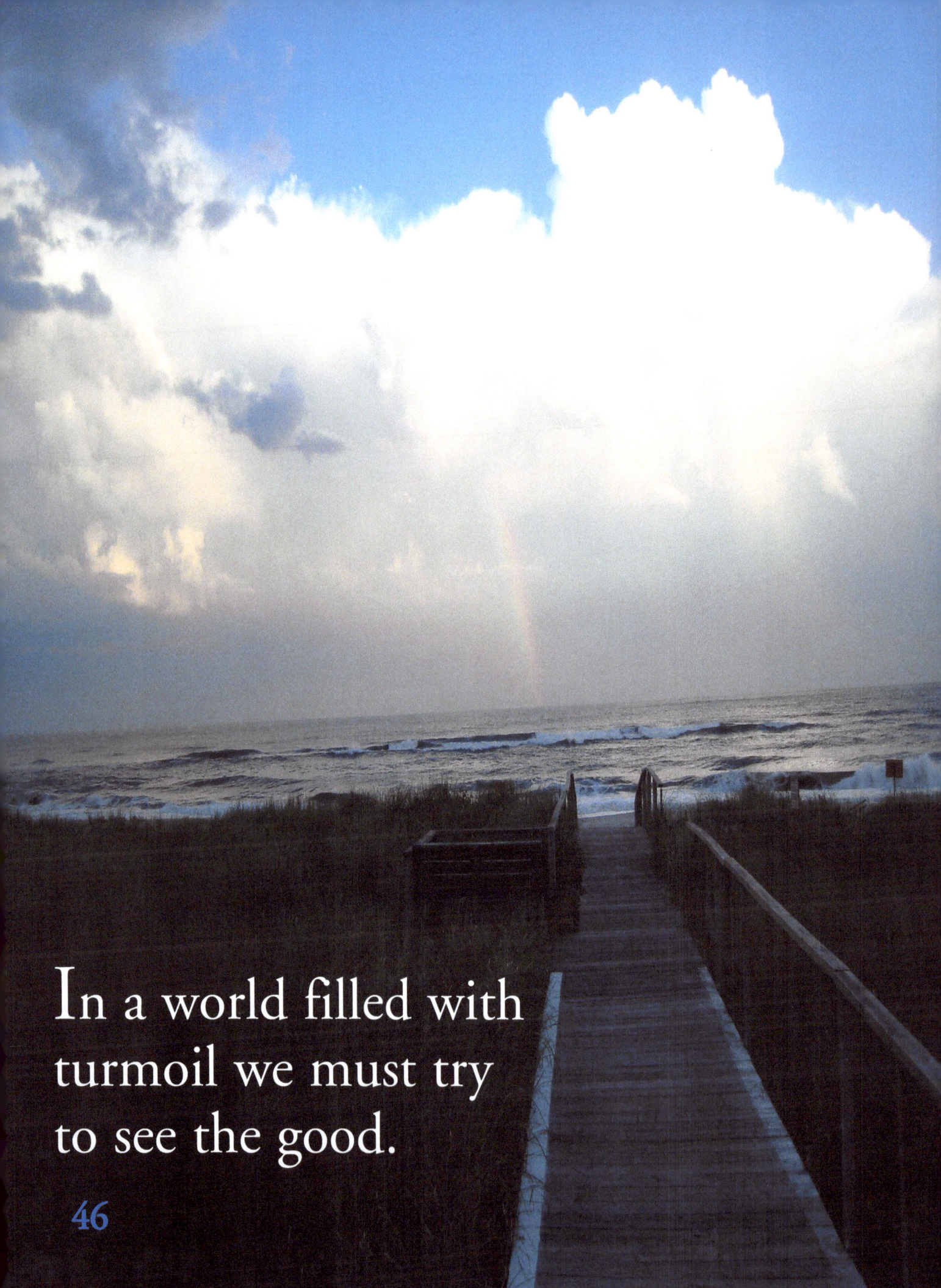
In a world filled with turmoil we must try to see the good.

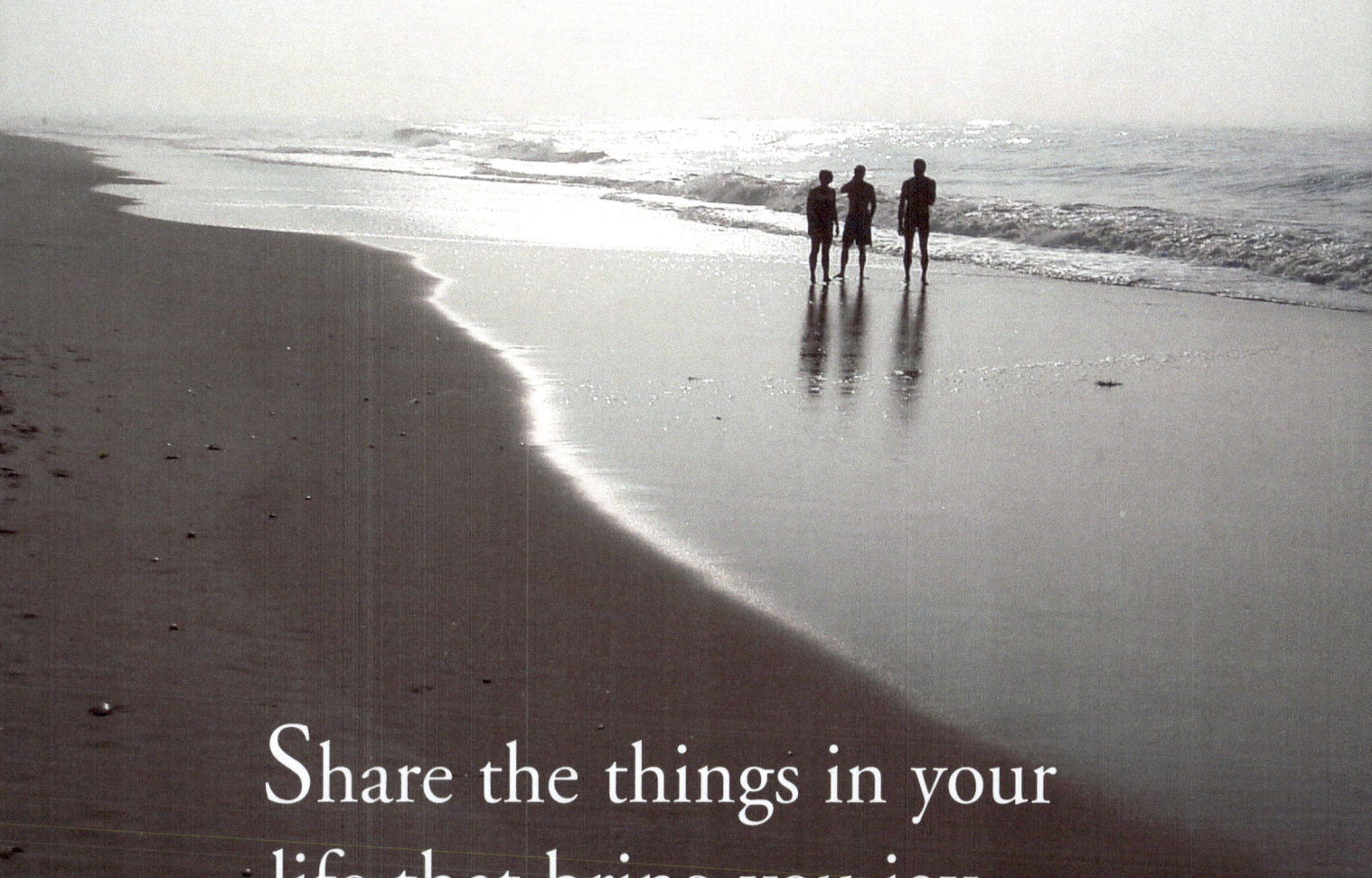

Share the things in your life that bring you joy.

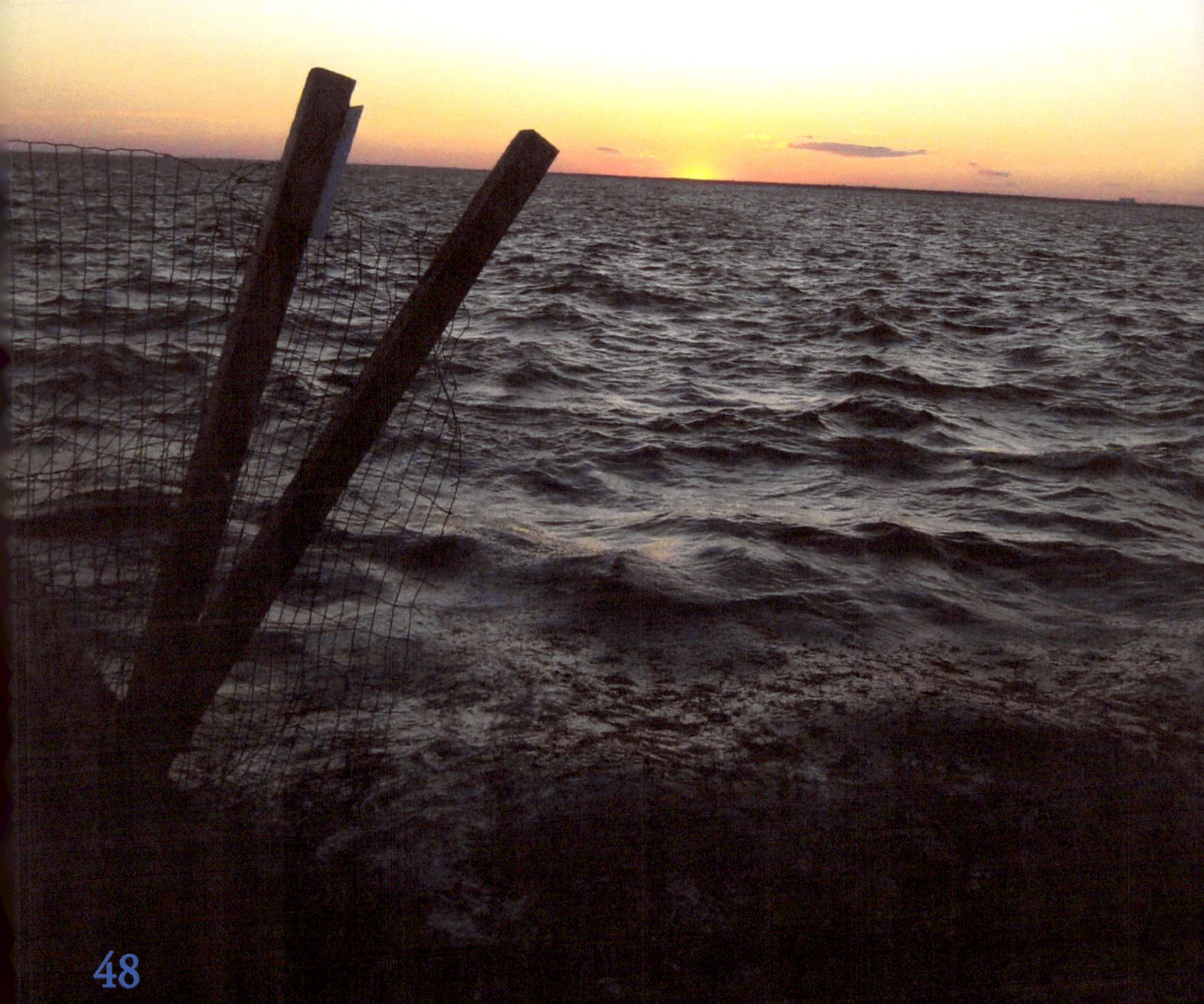

Don't let the chance to experience memorable moments slip away from you.

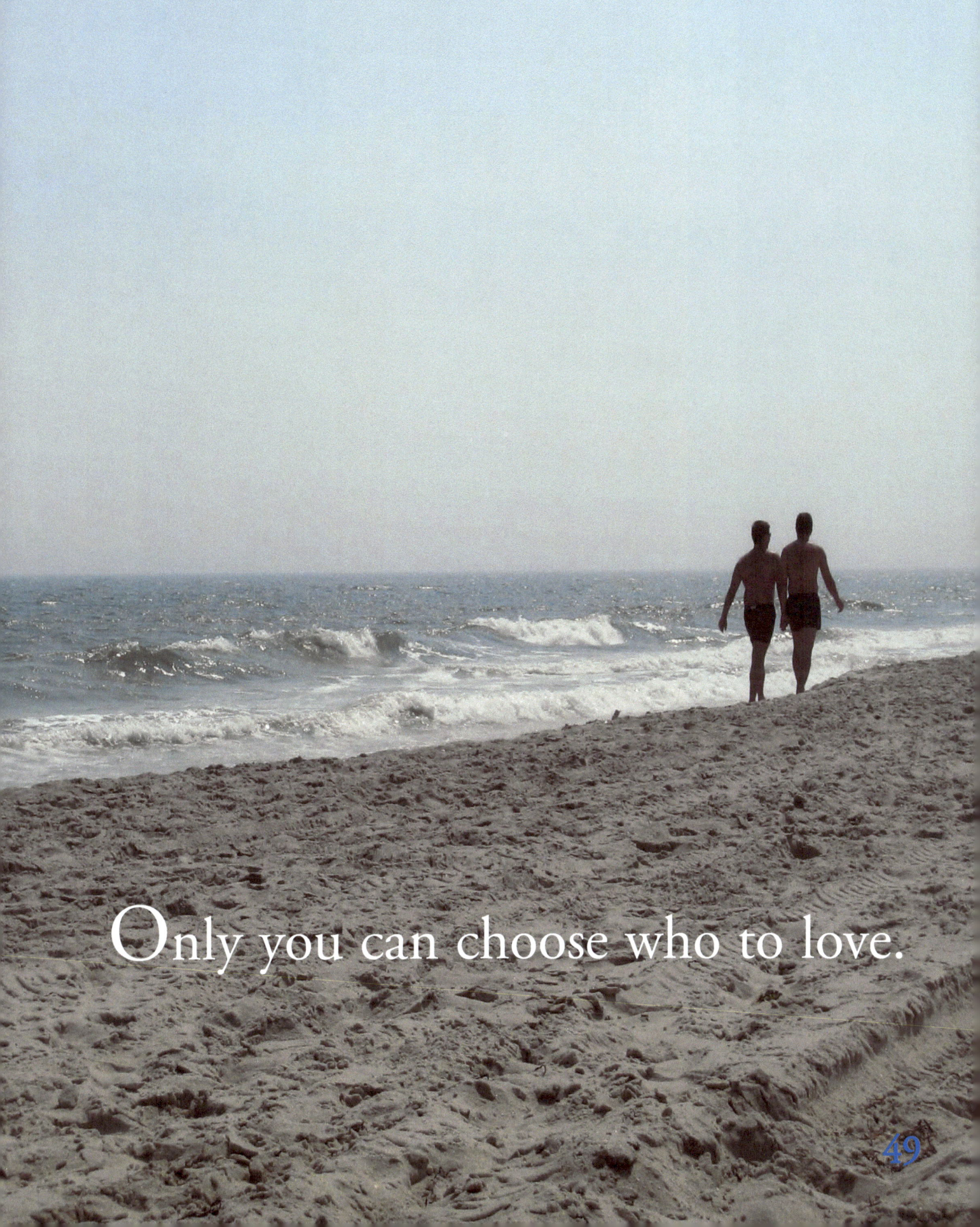

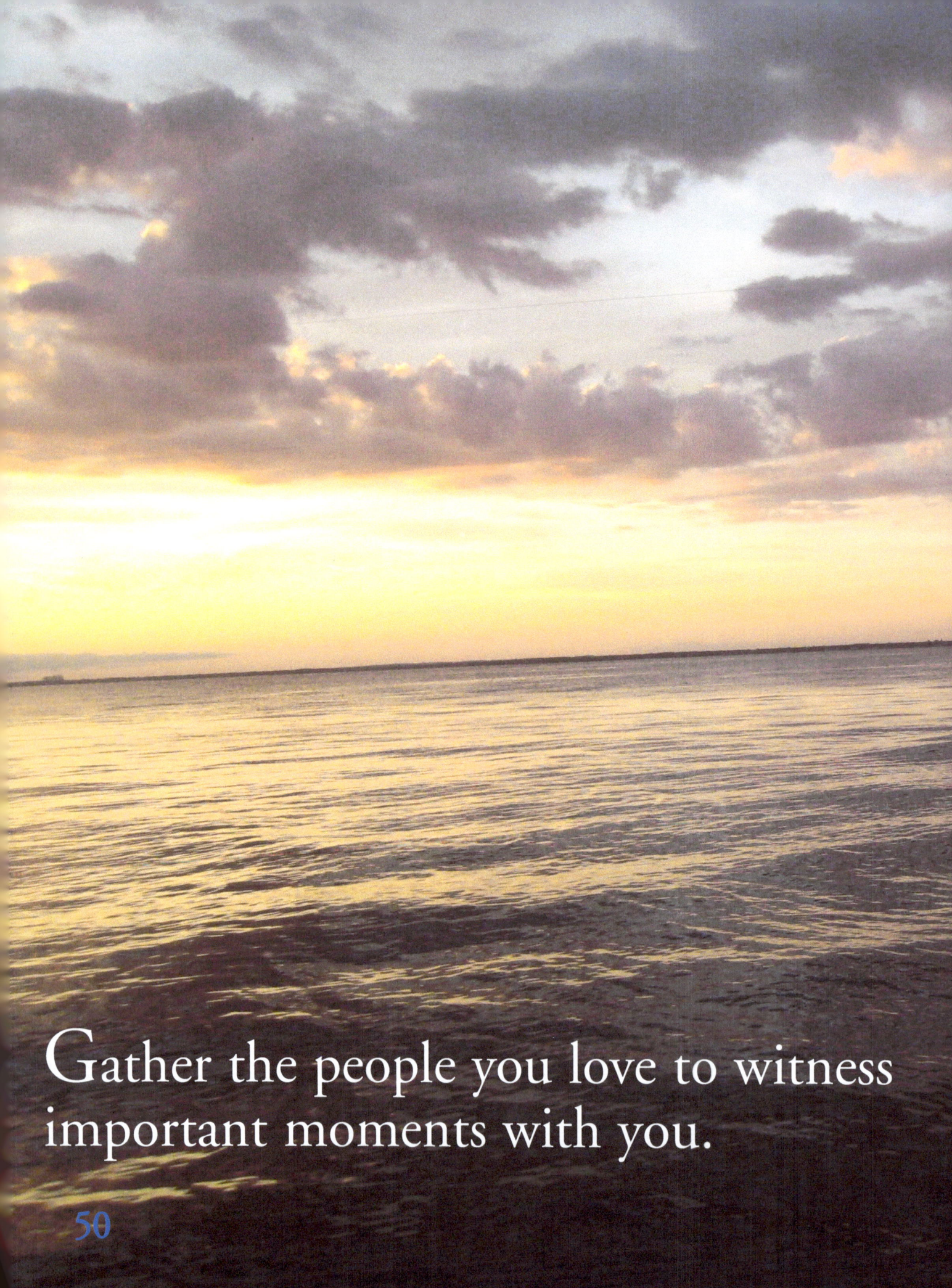

Gather the people you love to witness important moments with you.

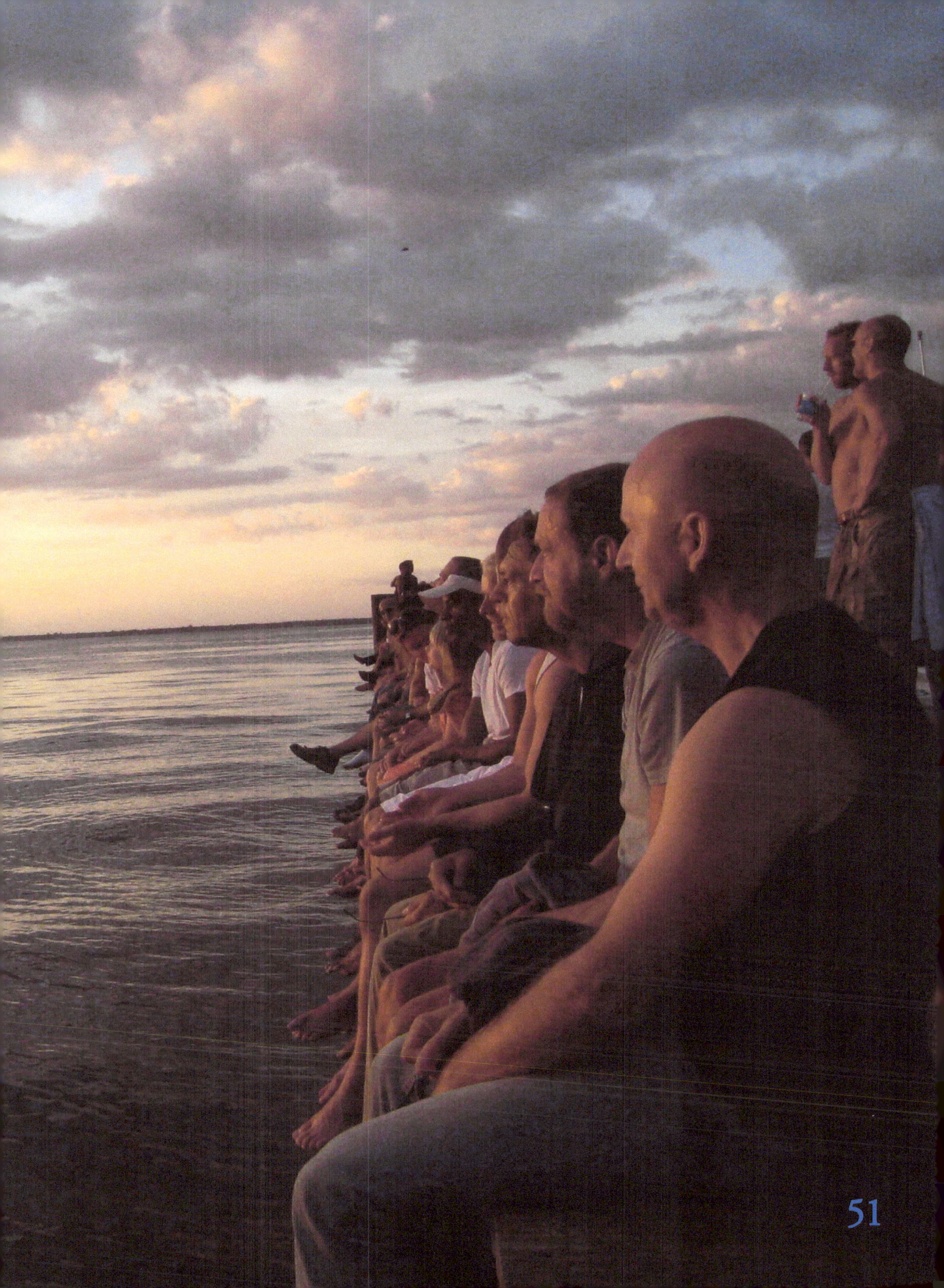

Take what you have learned and leave the rest when ending a relationship.

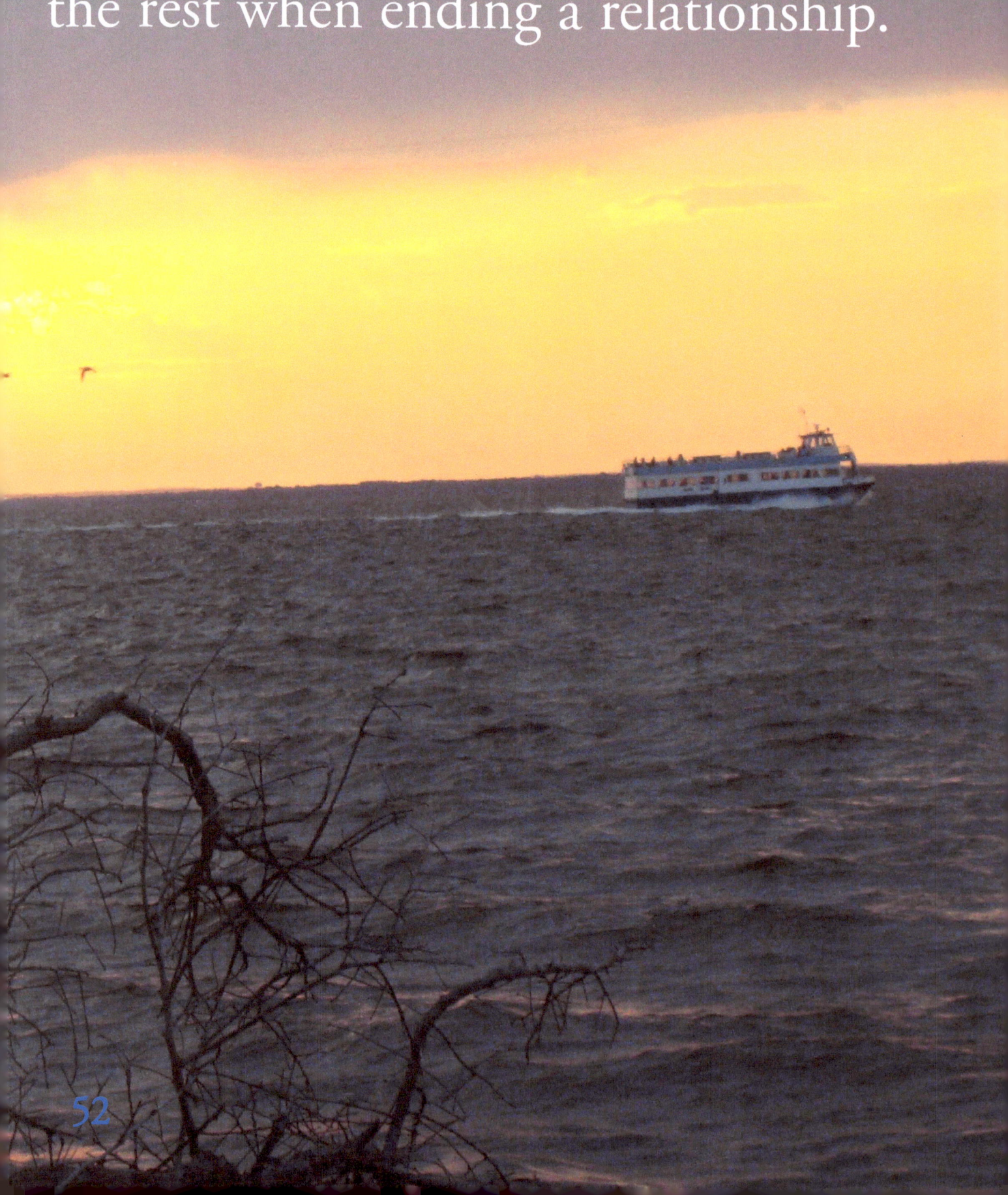

Don't wait for life to happen to you. Make things happen in your life.

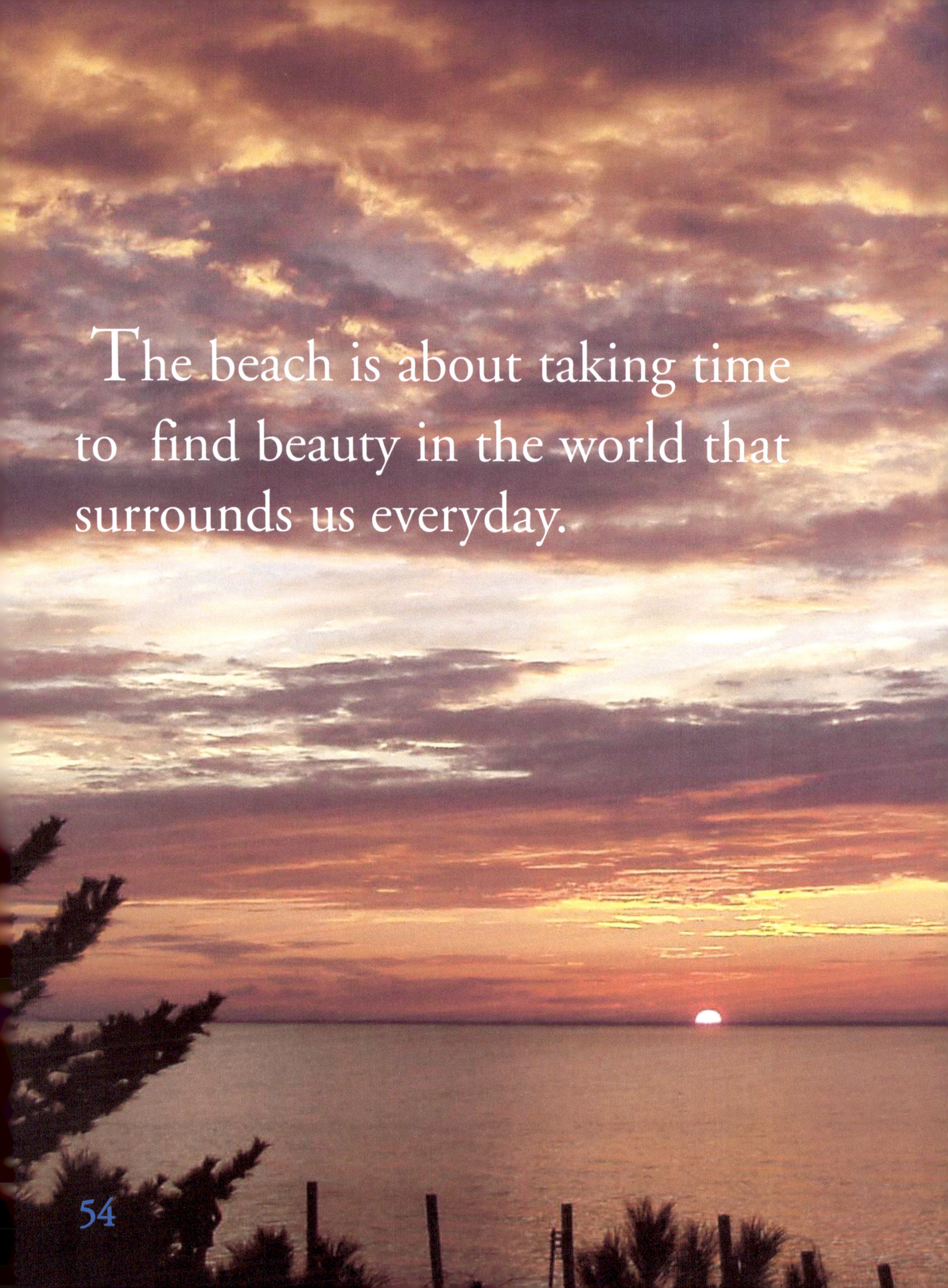

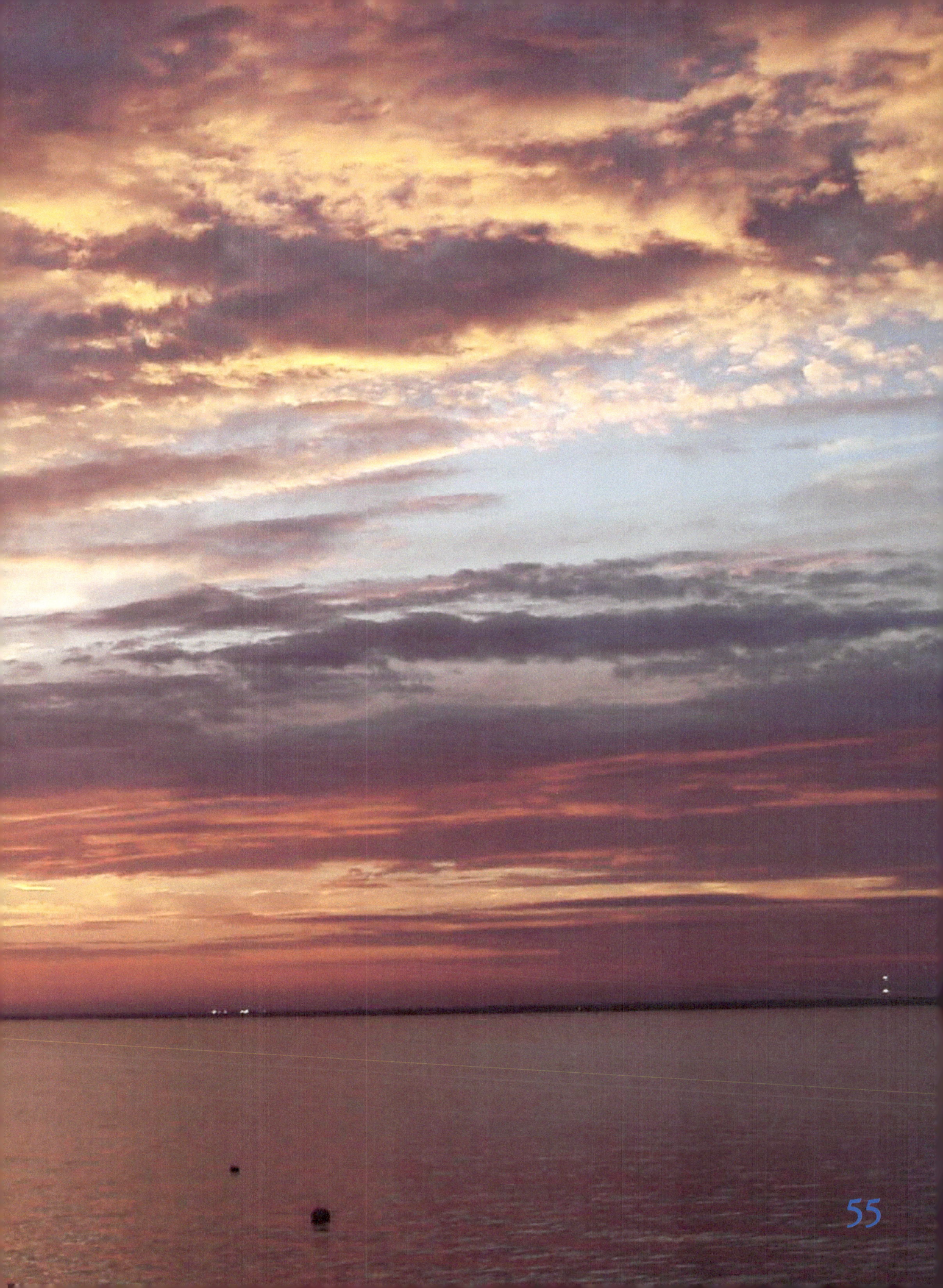

www.ingramcontent.com/pod-product-compliance
Lightning Source LLC
Chambersburg PA
CBHW051054180526
45172CB00002B/638